IMAGES
of America

CAMBRIDGE

IMAGES
of America

CAMBRIDGE

Edited by William Kerrigan

ARCADIA

Published by Arcadia Publishing
Charleston SC, Chicago IL, Portsmouth NH, San Francisco CA

Printed in the United States of America

Library of Congress Catalog Card Number: 2006920981

For all general information contact Arcadia Publishing at:
Telephone 843-853-2070
Fax 843-853-0044
E-mail sales@arcadiapublishing.com
For customer service and orders:
Toll-Free 1-888-313-2665

Visit us on the Internet at http://www.arcadiapublishing.com

For the citizens of Cambridge, an all-American city

CONTENTS

ACKNOWLEDGMENTS

This pictorial history of Cambridge was produced by history majors at Muskingum College in the fall term of 2005. The students selected the images, planned the layout, and wrote the captions. My job was limited to editing the finished product. Rebecka Hackett was responsible for the bulk of chapter 1, "Wheeling Avenue, on the National Road"; Alicia Seng took the lead on chapter 2, "Cambridge at Work"; Michelle Moore was responsible for most of the material in chapter 3, "Cambridge Life"; Allison Avolio put together chapter 4, "Disasters"; Jason Mattern researched and wrote captions for images of Cambridge's many historic commemorations. Those images were integrated into chapters 1 and 3.

The majority of the images came from the files of the Guernsey County Historical Society and the Finley Local History room in the Guernsey County Library; pictures of the early days of the Cambridge YMCA were provided by that organization. Thanks to the board of the Guernsey County Historical Society, the staff at the Guernsey County Library, and the Cambridge Area YMCA for allowing the students access to their photograph files. A number of individuals were generous in offering their advice and expertise, allowing us to complete this work. Special thanks to Kurt Tostenson, curator of the historical society, for sharing his deep knowledge of the community and these photographs in his care. Melissa Essex, chief librarian in the Finley Local History room, was also exceedingly generous in sharing her time and expertise in putting together this book. Andy and Janice Keith helped us identify some of the people in the *Daily Jeffersonian* pictures. Native Cambridgian Jerry Thompson also provided invaluable help identifying some of the photographs. And last but certainly not least, thanks are due to the patience and professionalism of the staff at Arcadia Publishing. Without their hard work, this could not have been completed.

Compiling a book such as this one requires material resources as well as human ones. This book could not have been completed without the financial support of the Muskingum College Center for Planning and Development. The center provided laptops and scanners and covered all of the incidental costs related to researching, compiling, and editing this book. Royalties from this volume will go to the center so it can continue to provide community internship opportunities for Muskingum College students. Special thanks go out to Dr. Walter Huber, director of the center, for recognizing the value of this project and to Muskingum College president Anne Steele and the board of trustees for seeing the promise and potential of the center.

Finally, as a relative newcomer to the region, it was an immense privilege to have the opportunity to help put together this book on Cambridge. One of the things I have learned about Cambridge and southeastern Ohio in my eight years teaching here is that this is a region that cherishes its past and is deeply committed to preserving it. Thanks to generations of civic-minded Cambridgians, the city has remained the jewel that it is, a place that has managed to preserve much of the best aspects of American community.

—Dr. William Kerrigan
Department of History
Muskingum College
New Concord
December 2005

INTRODUCTION

What follows is a pictorial history of Cambridge from the 1870s to the mid-1960s, when Interstates 70 and 77 were cut to the south and east of the city. Cambridge was shaped by three geographic and economic realities: its location astride the region's most important transportation corridor, the development of industries that drew on the specific natural resources of the region, and its topography and hydrology. These three factors are highlighted in the book.

Situated on Zane's Trace (the first path cut by white explorers across present-day Ohio) and later the historic National Road, Cambridge was the site of the first legal bridge built in the Northwest Territory. Its location on this main thoroughfare, along with its success in becoming the county seat when Guernsey County was formed in 1810, were keys to its early growth and explain why it remains the largest city in the county. The arrival of the Baltimore and Ohio (B&O) Railroad in the 1850s solidified its place as an important commercial site along the region's main transportation corridor. In 1962, Interstate 70 was cut about two miles south of downtown; a few years later, Interstate 77, running north to south along the city's eastern edge, was completed. At first, this development appeared to be a threat to Cambridge's National Road main street, as it drew traffic away from downtown to the interstates, and new businesses emerged along the exit ramps. However, after a period of economic decline on Wheeling Avenue, a tremendous revitalization effort is underway. Historic buildings have been restored and are finding new uses as coffee shops, gift and antique shops, and office buildings. It now appears that the construction of the interstates saved this historic treasure by leaving it frozen in time. Today the National Road is in many ways a "fossil record" of life in the region in the 1950s and earlier.

Early settlers to the region were a mix of English, Welsh, Scot-Irish, German, and African American. Guernsey County takes its name from the Isle of Guernsey, from whence some of its first settlers came. These earliest settlers earned a living by serving travelers who passed along Zane's Trace and later the National Road and the B&O Railroad or by serving the commercial needs of the families farming the rolling terrain in the surrounding countryside. The farms in the region were smaller and poorer than those laid out in the fertile flatlands of western Ohio; a typical quarter-section farm in the region contained a mix of tillable land and hillside pasture, and farmers engaged in mixed subsistence patterns to earn a living. Cambridge offered them a place to market their agricultural surpluses and to buy needed supplies. The years after the Civil War brought new industries and new immigrants to the region, drawing on the other natural resources the region had to offer. First was coal, which attracted large numbers of southern and eastern European immigrants to the area, most of whom first lived in the coal camps that sprang up on the southern and eastern edges of the city. Soon these new immigrants were placing their own imprint on Cambridge. On weekends, Slovaks, Greeks, and others poured into the city, spending their hard-earned dollars in Cambridge's shops, restaurants, and (later) movie theaters. Some would start their own local businesses. By the late 19th century, immigrants and native-born people were finding employment in other industries, most importantly the pottery and glass factories that began to flourish. These industries, more than anything else, shaped the culture of this community and are central to its history. Lifelong residents are often willing to share stories of the parents and grandparents who worked in these industries, and conventions and auctions for glass and pottery collectors are regularly held in the city.

A third factor that has shaped the history of Cambridge and the region is topography and hydrology. Situated in the foothills of Appalachia, the landscape of Cambridge and its environs is a patchwork of hills and hollows. Snaking through this landscape are the slow-moving, muddy waters of Wills Creek, which wind their way around and through Cambridge before ambling in a northwesterly direction to meet up with the Muskingum River. Wills Creek has long been a source of recreation but also a plague, as it frequently floods low-lying areas of the city. Flood stories, and to a lesser extent snowstorm and thunderstorm stories, make up an important part of the local folklore.

These three themes: Cambridge's historic main street on the National Road; "Cambridge at Work" in the coal, pottery, glass, and other industries; and memories of natural disasters are each featured in a separate chapter. In addition, a chapter on Cambridge life chronicles the city's civic, social, and recreational history, including its historic band and its sports teams.

One

WHEELING AVENUE, ON THE NATIONAL ROAD

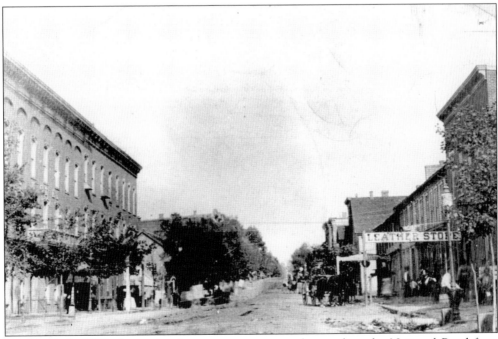

On March 3, 1825, the national government approved extending the National Road from Wheeling to Zanesville along the straightest possible line. The road became the main artery through Guernsey County and passed through Cambridge near the route of the first road through the region, Zane's Trace. This photograph is of the National Road/Wheeling Avenue in 1886.

The double covered bridge was built when the National Road came through Cambridge in 1828. A tablet at each end of the bridge informed travelers that the bridge was built by "J. P. Shannon, Undertaker; L. V. Wernwag, Architect; J. Kinkead, Mason." The bridge was in use for almost a century.

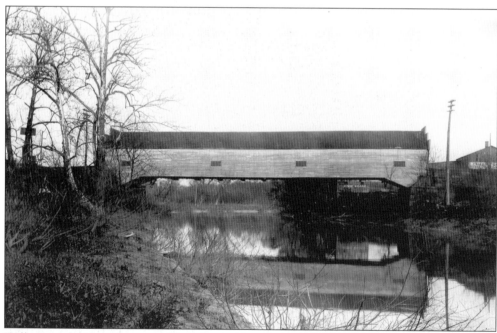

Wills Creek had long been a problem for travelers through the area. When the road was known as Zane's Pike, travelers had to use a ferry to cross the deep stream. Later the ferry was replaced by a bridge built of logs with a puncheon floor. The man who owned the ferry and tavern beside Zane's Pike, Zaccheus A. Beatty, decided to finance the bridge because he felt it would be profitable to his business. Beatty collected a toll from those who crossed his log bridge. This photograph shows a side view of the later double covered bridge spanning Wills Creek.

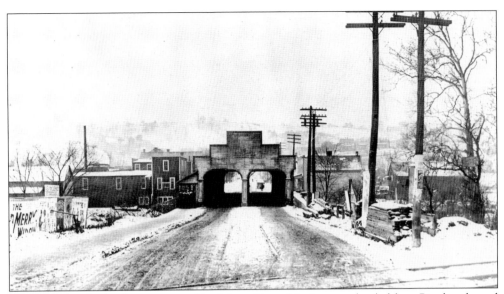

The bridge was built of stone quarried in Adams Township. Iron was hauled from Pittsburgh, and the heavy nails and spikes were handmade. The bridge was actually built in the field adjacent to Wills Creek. Then a canal was dug to divert the water under the bridge.

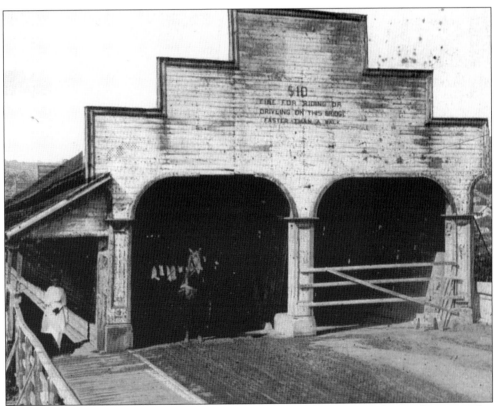

Painted above the north end of the bridge was the warning "$10 fine for riding or driving on this bridge faster than a walk."

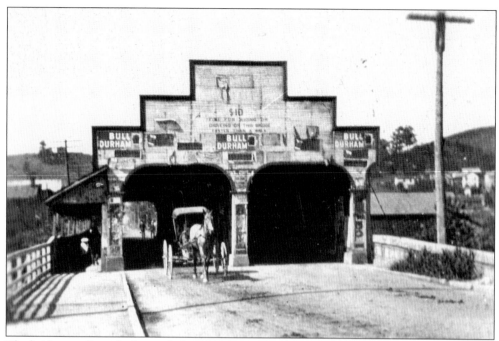

The bridge was lit with electric lights after this technology reached Cambridge. The bridge also offered an excellent place for advertisements because of its location on Wheeling Avenue and the National Road.

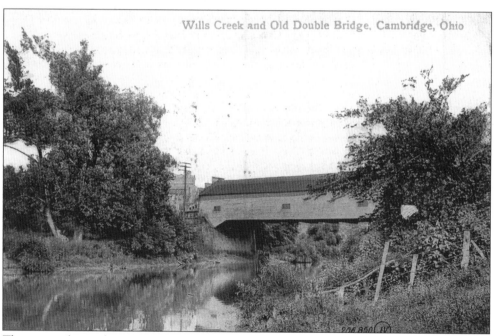

This postcard provides a water view of the old bridge from Wills Creek. The usually slow-moving Wills Creek carries much sediment from the farmlands through which it meanders and is prone to overflowing its banks after heavy rains.

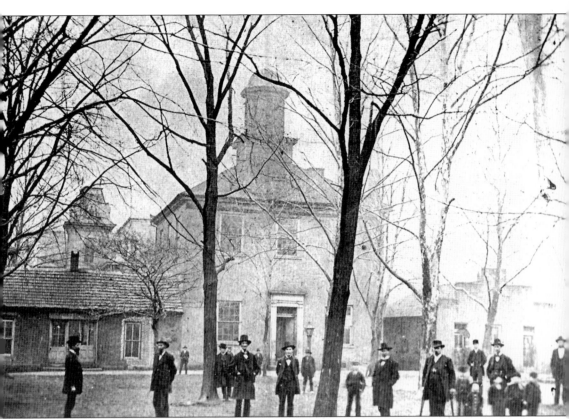

Construction on the first courthouse began in 1810, and the building was completed in 1818. The landscaping of the grounds was not completed until 1841. However, it was opened for court in August 1813 when the upper story was finished. After completion, the courthouse provided a gathering place for many facets of Cambridge life. Civil, religious, military, social, and political meetings were all held at the courthouse because it provided a large space where many could gather. In this photograph, the building at the left held the auditor's and treasurer's offices, while the building at the right housed the offices of the clerk and recorder. The building served for 70 years and was only repaired once, in 1854, when the spire was struck by lightning. The building became too small for the growing county, however, and the old courthouse was torn down to make room for a larger building. Pictured from left to right are (foreground) W. E. Boden, John Robins, William Smith, James Buchanan, Capt. John Bell, Robert Hammond and children, William Hanna, and Charles Rabe.

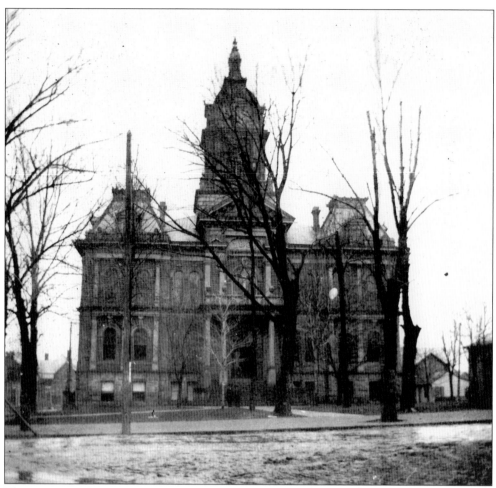

The necessity of a new building led to the design and construction of the present courthouse. The cornerstone for this building was laid on August 4, 1881. According to one account, a crowd of 10,000 gathered for the celebration, which included a picnic and parade. The building was completed and dedicated on September 11, 1883. The final cost for the courthouse exceeded $100,000.

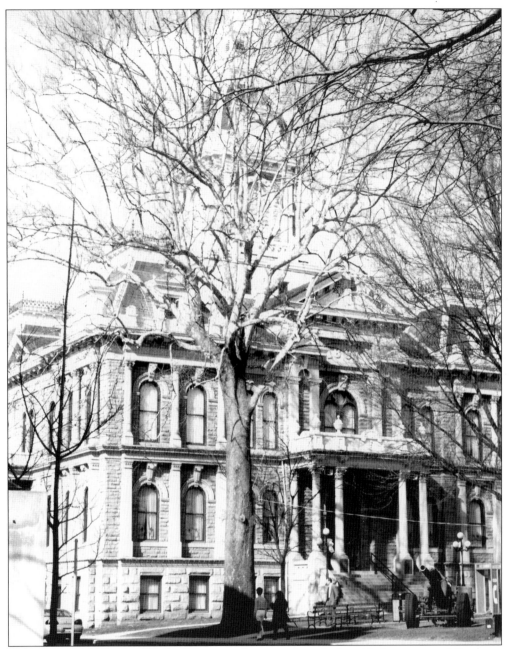

The courthouse as it stands today has come a long way from the humble beginnings of Guernsey County. The county was organized in a small tavern named the Tingle Tavern on April 23, 1810. This building at Lot 9 Wheeling Avenue provided a meeting place for the three judges appointed to establish the county. Judges Thomas B. Kirkpatrick, Jacob Gomber, and Robert Speer appointed a sheriff, prosecuting attorney, surveyor, recorder, and three commissioners at that first meeting. Tingle Tavern was also the location for the first court cases of Guernsey County. A courthouse was begun shortly after the county was founded, but until it was usable in 1813, cases were tried in Tingle Tavern. Now all Guernsey County cases are held in the beautiful courthouse located on Wheeling Avenue in Cambridge.

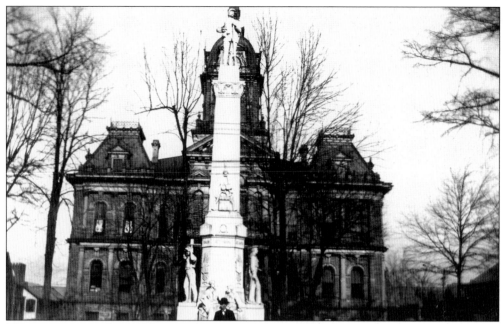

The monument in front of the courthouse was dedicated on June 9, 1903. The monument cost $15,000 to commission, and this money was raised by having the Ohio legislature pass a bill allowing Guernsey County to tax the residents for this project. The design of the monument includes a private soldier at the apex, a sailor on the east side, an artilleryman on the west side, a cavalryman on the north side, and on the south side, facing Wheeling Avenue, a woman, said to represent history, reciting to the children at her side the achievements of Civil War soldiers.

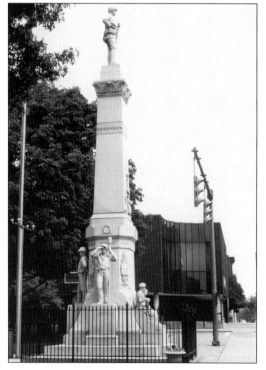

The glorious $15,000 blue gannet Guernsey County Soldier's Monument was erected in 1903 and dedicated on June 9 of that year along with the $18,000 library in Cambridge's public Court Square. The inscription on the monument reads, "Dedicated to those who served in the War of the Rebellion, 1861–1865."

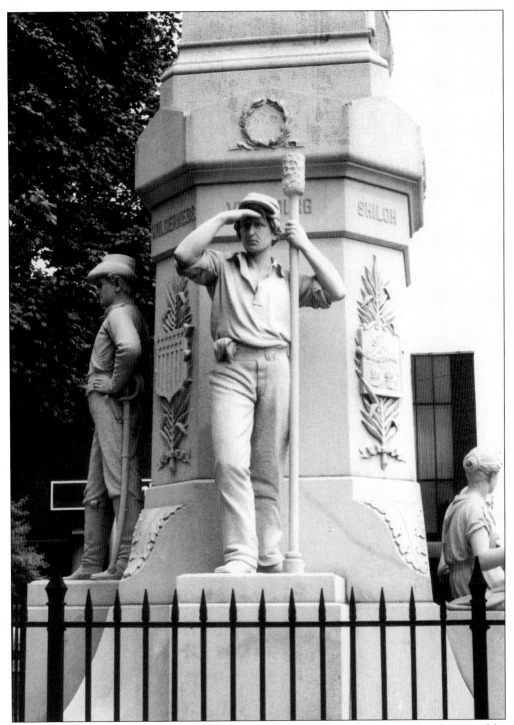

The monument was rededicated on June 18, 1995, after it had been restored and repaired by donations raised by the Daughters of the Union Veterans of the Civil War. The names of major battles in which Guernsey Country residents fought—including Shiloh, Vicksburg, Wilderness, Atlanta, Winchester, and Antietam—are recalled in its octagonal base.

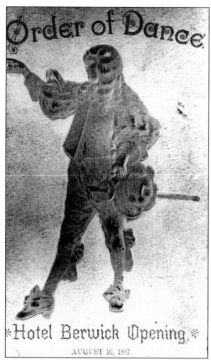

Col. Joseph D. Taylor purchased the property at 607 Wheeling Avenue where he would build the Hotel Berwick in 1866. He first built a residence on the property after his return from the Civil War and marriage to Elizabeth A. Hill of Maine. He first built a home on the lot, and they lived there until the 1880s when a new house was built north of town. The colonel decided to build a hotel on the property and named it the Berwick after the hometown of his bride, North Berwick, Maine. This program is from the dinner and grand ball held on August 16, 1887, to celebrate the opening of the hotel. Capt. W. M. Farrar was toastmaster at the dinner, and toasts were made to the builder, the proprietors, the town, the people of the town, and the guests of the hotel. The opening was an elaborate social affair for the citizens of Cambridge.

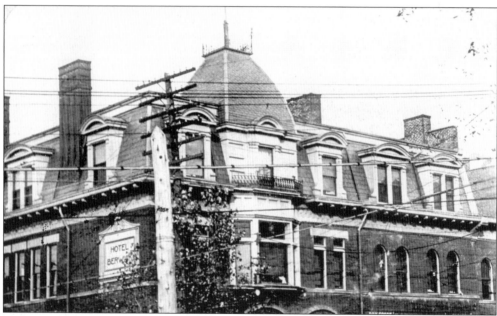

By 1900, the Hotel Berwick had twice been threatened by fire. The great fire of 1891 burned the north side of Wheeling Avenue from Sixth Street to the alley east. Colonel Taylor, who owned the hotel, determined to rebuild, however, and the hotel was opened again in 1894 by J. P. Murdough. Fire struck again in 1895 and destroyed many of the other buildings Colonel Taylor had erected since 1891, but the Hotel Berwick was saved by a fire wall on the east side. The colonel leased the hotel to Charles Mast and H. V. Atkinson, and they controlled the hotel until the 1930s.

Ogiers Drug Store was located at 816 Wheeling Avenue in 1889. Today the building is known as the Firestones Building. At Ogiers, one might find a little of everything. The windows advertise wallpaper, beyond the medicines and ice cream offered inside.

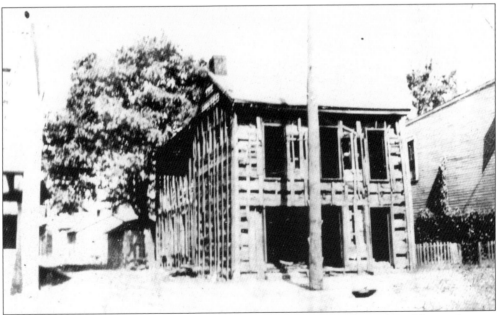

The Holler Tavern, Hope and Anchor was a large two-story hewn log L-shaped house that was weatherboarded. It was built prior to 1812 and was designed to conform to the natural lay of the land on the crown of the hill. The tavern was run by Joseph Holler and in its best days was also the stage office. The building lay on Lot 7 of Wheeling Avenue and was also converted into a tenement house before it was torn down.

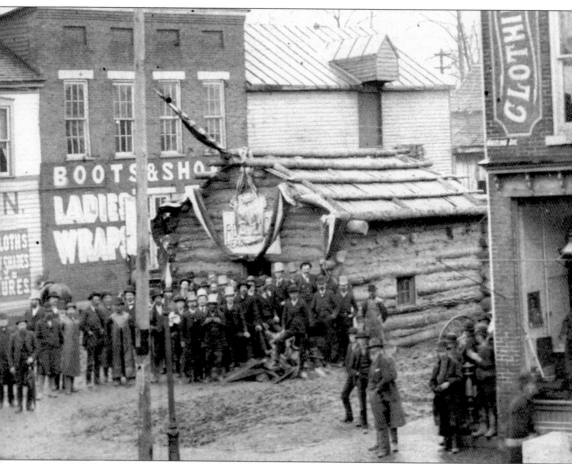

In 1888, Republicans decided to have their own "Log Cabin Campaign," to remind voters that they were the party of Lincoln and in the tradition of the Whig campaign of 1840. To promote unity within the Republican party, each township of Guernsey County was asked to donate two logs for the construction of a log cabin on South Eighth Street between Rainey's and Craig's corners. The cabin would serve as Republican headquarters for the 1888 election.

This photograph is of Frank Raymond's dry goods store. The store was located in the Berwick block of Wheeling Avenue. Dry goods stores provided nearly all the necessities of life, and there was always one or more of this type of store for Wheeling Avenue shoppers.

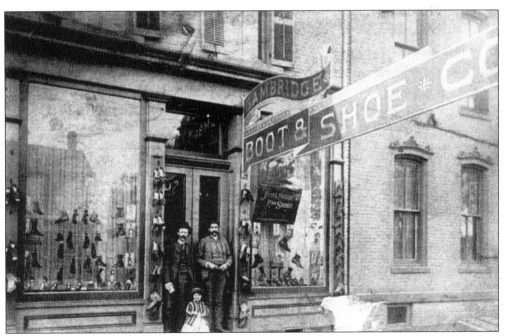

The Cambridge Boot and Shoe Company may have been run by one of two businesses. According to the 1889 Cambridge business directory, both George H. Boetcher and A. Hubert owned boot and shoe stores on Wheeling Avenue. Boetcher's store was located at 749 Wheeling, while Hubert's was located at 709 Wheeling.

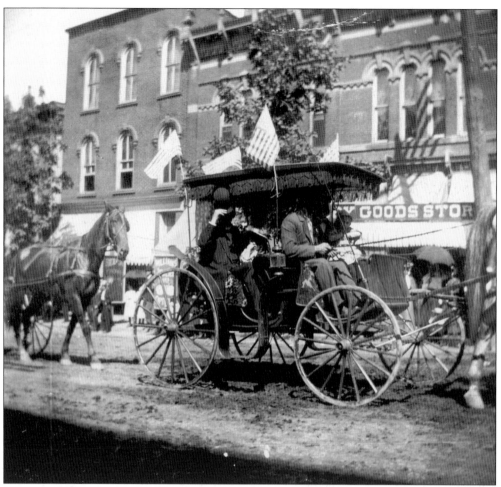

This parade photograph from 1894 shows Wheeling Avenue in the days when the horse and carriage remained the primary mode of transit. This world would soon fade away, with the arrival of the automobile, the streetcar, and the paved road.

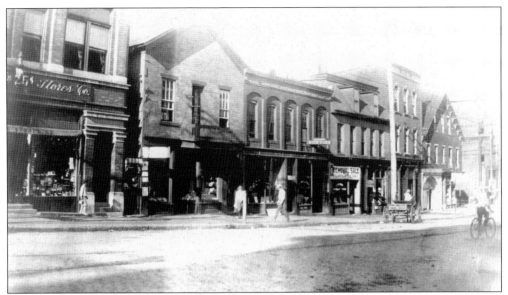

Notice the boy wearing knickers on the far left in this photograph of the south side of Wheeling Avenue prior to the construction of the Potter Davis building.

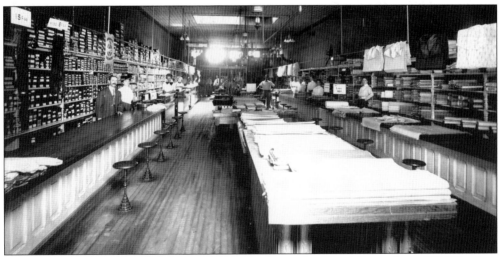

In 1905, Potter Brothers Dry Goods, located next to the Hotel Berwick at 607 Wheeling Avenue, was owned by Maurice R. and Chester R. Potter. The store carried merchandise such as dry goods, ladies' furnishings, cloaks, suits, and furs. They also carried items for the home, including window shades, curtain draperies, and Haviland china. An advertisement for the store at this period read as follows: "No Higher in price than the not so good kinds." In the left foreground, from left to right, are Mr. and Mrs. Chester R. Potter.

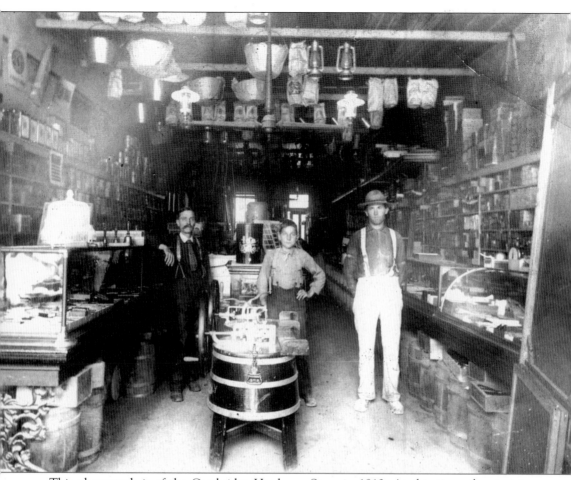

This photograph is of the Cambridge Hardware Store in 1913. At this time, the proprietor was R. Kirkpatrick, but the store was purchased by Maurice R. and Chester R. Potter in 1915 and became Potter's Hardware. The men in the photograph are (from left to right) employees Robert I. Schultz, George Schultz, and Billy Willis.

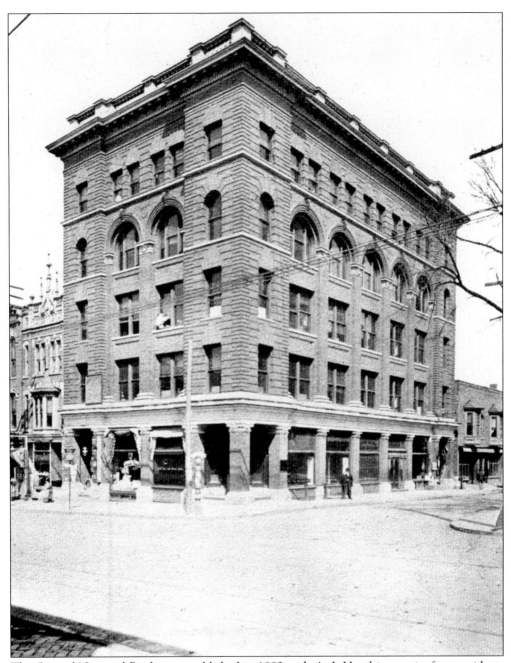

The Central National Bank was established in 1882 with A. J. Hutchison as its first president. This five-story building was completed in 1904, with the first floor used for banking and the other floors used for offices. The building is located at 749 Wheeling Avenue.

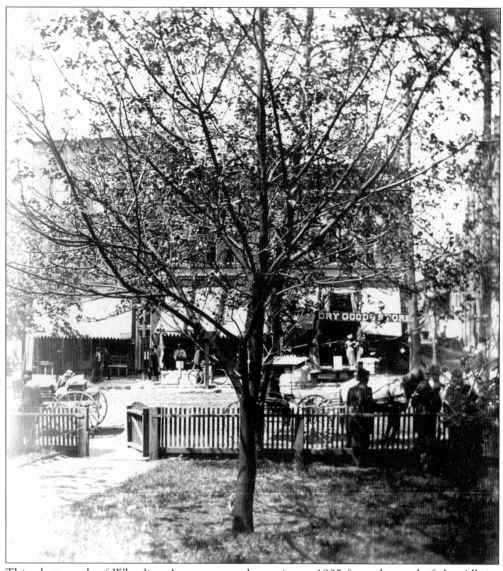

This photograph of Wheeling Avenue was taken prior to 1905 from the yard of the Albrite home. This house was razed to prepare the site for the Masonic temple. The cornerstone was laid for the temple on July 4, 1905. The building exists to this day at this address.

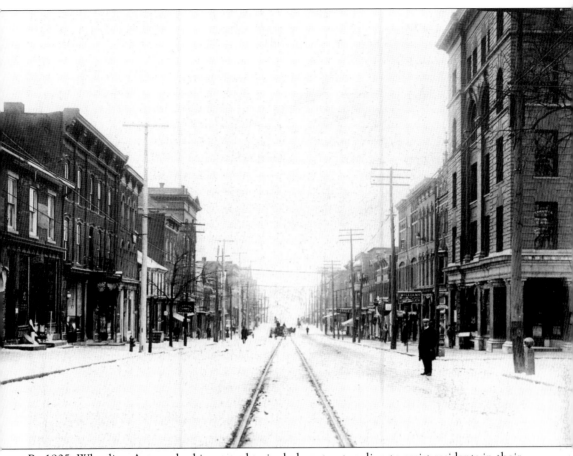

By 1905, Wheeling Avenue had improved to include a streetcar line to assist residents in their travel about Cambridge. Travel at this time was also accomplished by horse and wagon, as is visible farther down the street. Western Wheeling Avenue was dominated by the presence of the Central National Bank building, the first structure in the right foreground. The man in the right foreground is chief of police John Long.

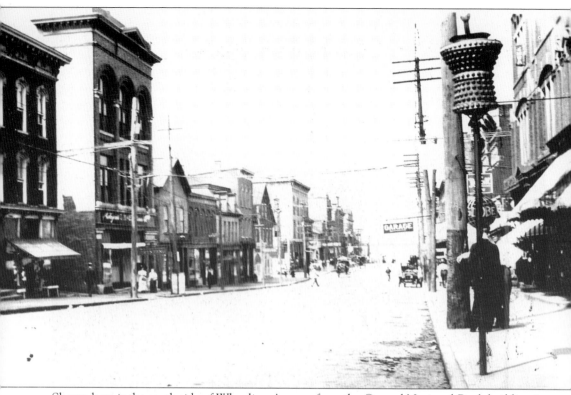

Shown here is the south side of Wheeling Avenue from the Central National Bank building in 1907. Electric telephone wires and lights line the street.

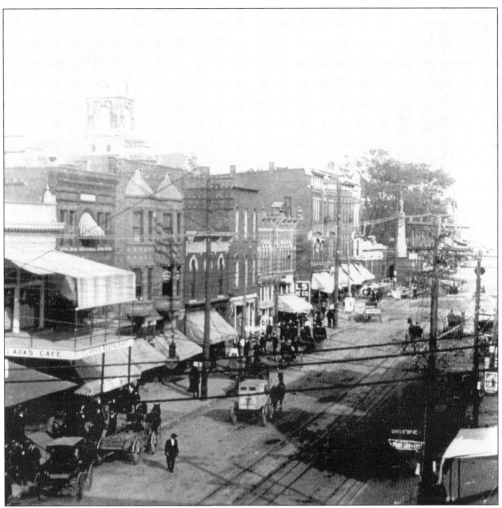

This view is of the north side of Wheeling Avenue looking east from Seventh Street in 1907. From here, the cupola of the courthouse is visible, as well as a bustling National Road. Not only are there horses and wagons and streetcar lines but also the first instances of the horseless carriage (left foreground).

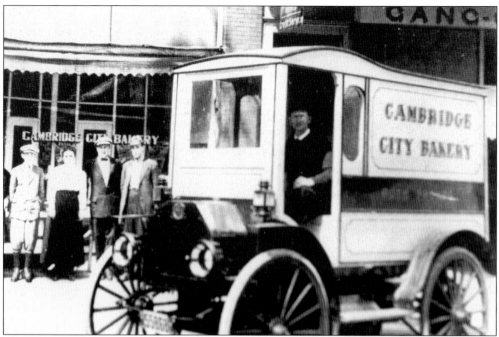

The Cambridge City Bakery, found at 839 Wheeling Avenue, had John L. Bruner as its proprietor. This photograph shows both the bakery and one of the trucks used to make deliveries. The 1910–1911 Cambridge directory lists the home telephone as 220 and the bell 173-J.

The Cambridge Light and Power Company, later the Cambridge Electric Company, was the headquarters of General Electric Works in Cambridge. The building sat at 758 Wheeling Avenue and was managed in 1910 by a man named Hays.

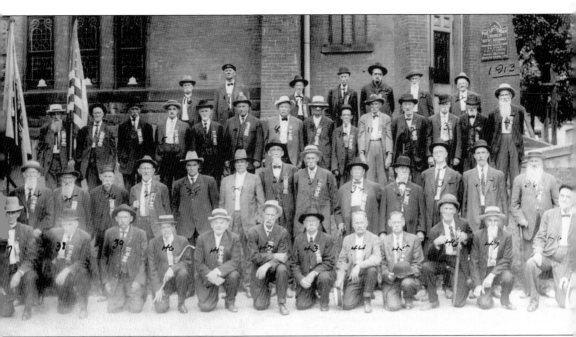

The Cambridge post of the Grand Army of the Republic was first formed in 1870, but with dark memories of the war still haunting many young veterans, few seemed interested in the organization, and it was largely inactive during the next decade. In 1884, the post was reestablished, with 27 members at that time—a small fraction of the more than 2,000 county residents who served. As the harshest memories of war faded, aging veterans appeared more interested in participating in Grand Army of the Republic reunions, and membership grew to several hundred before deaths caused those numbers to diminish. The group marched in uniforms in holiday parades and held periodic reunions, most commonly in Taylor's Grove. In 1913, 49 members turned up for this reunion photograph; a decade later, few would still be alive.

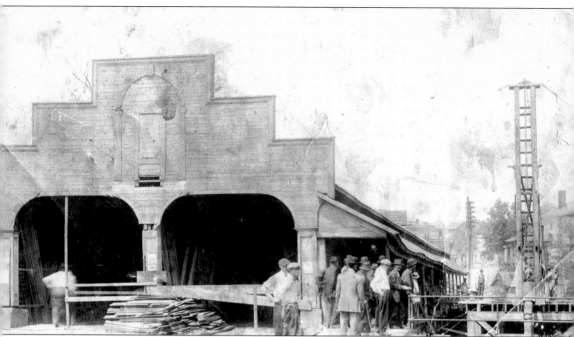

The flood of 1913 weakened the double covered bridge, and the structure was condemned to be torn down. A new bridge had to be built. However, there were obstacles to these efforts. The location of the bridge on the National Road brought into question who should be responsible for financing a new bridge. There was also the question whether the bridge should also span the railroad tracks, eliminating a dangerous crossing. This brought another possible financier into question. The city of Cambridge spent 10 years using a purportedly safe temporary bridge while the national, state, county, and city governments and the railroad companies decided who should fund the new viaduct.

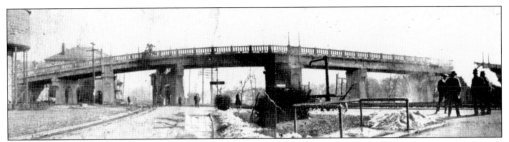

The contract for the new viaduct bridge was awarded to Hickey Brothers Construction Company of Columbus. The cost for the endeavor was met by the state of Ohio, Guernsey County, and the B&O and Pennsylvania Railroad companies. Total expenditures for the bridge reached $200,000.

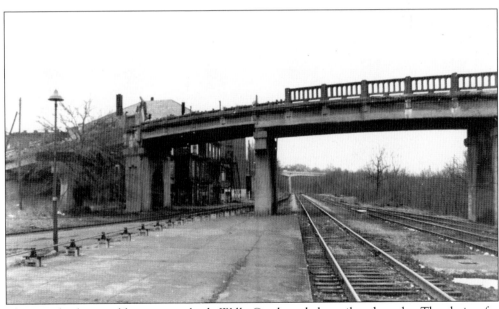

The new bridge would now span both Wills Creek and the railroad tracks. The design for the bridge had an approach at each end of the 590-foot bridge with a grade of nine percent. Besides the driveway for vehicles that was 24 feet wide, the bridge included a walkway for pedestrians on the east side that was 6 feet wide. When the bridge was formally opened on Tuesday, January 20, 1925, it was announced by the shrieking of factory whistles and the sounding of hundreds of automobile horns

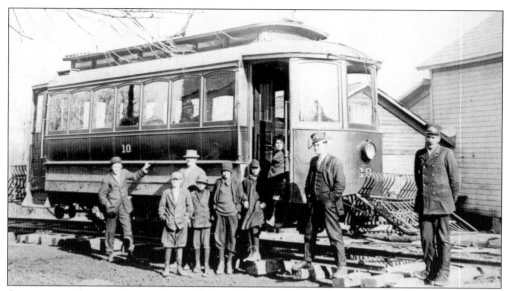

Streetcars and interurbans were symbols of the modern age at the start of the 20th century. The first streetcar line was opened by the Cambridge Consolidated Company in 1902 and ran down Wheeling Avenue from Eleventh Avenue to Fourth Avenue before turning north to the railroad crossing at Foster Avenue. It eventually extended south down Eleventh Avenue to Woodlawn Avenue in East Cambridge. Another line extended from the west entrance of the covered bridge through the south side, and one traveled north along Eleventh Avenue to Gomber Avenue, east to Highland Avenue, and then up to the Northwood cemetery.

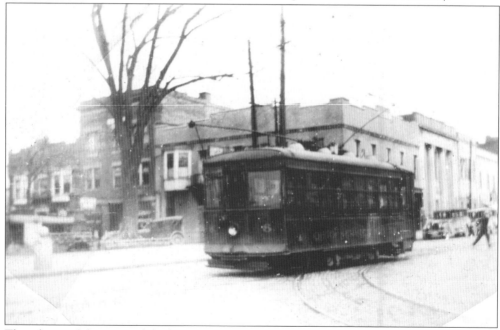

The advent of the automobile doomed the streetcar, as drivers did not like to share their road space. On January 31, 1927, Cambridge's last streetcar line was shut down. An interurban service to Byesville and Pleasant City, along the rails currently used by the Byesville Scenic Railroad, was also abandoned at this time.

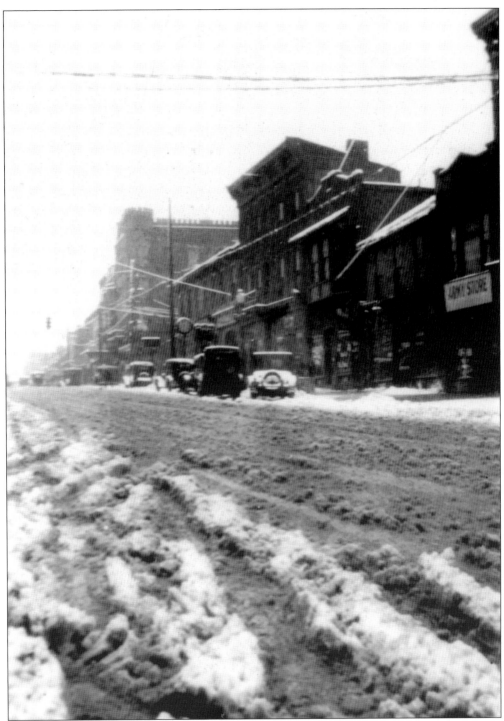

Wheeling Avenue in 1932 continued to reflect the growing importance of the automobile. In this photograph, one can imagine the challenges of taking these vehicles down Cambridge's main drag in the winter. Muddy snow and slush cover the roadway, posing a hazard for motorists driving and parking downtown.

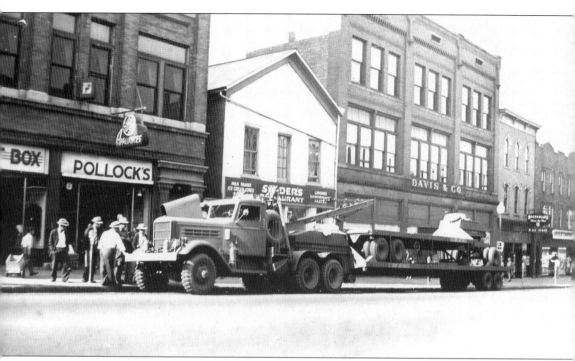

Wheeling Avenue continued to change. By 1943, the streets were paved instead of brick, and more modern buildings replaced homelike structures. This photograph shows a government truck and airplane transport. The carrier parked on the National Road en route to the seaboard on September 1. Thus, Cambridge played a role as a stopping point for any traveler on the National Road, including those helping the war efforts.

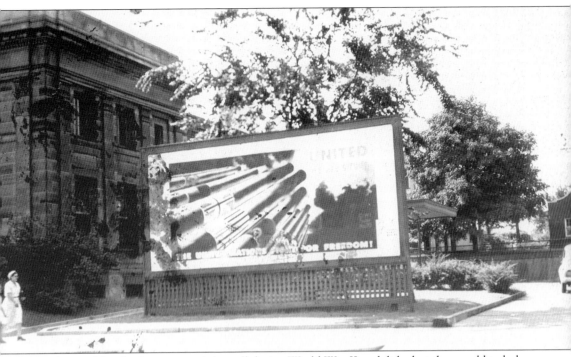

Residents of Cambridge answered the call during World War II and did what they could to help the war effort here at home. Billboards like this one, constructed on Wheeling Avenue next to the post office, reminded Cambridgians that "United We Are Strong" and celebrated the alliance with America's wartime allies, including the Soviet Union.

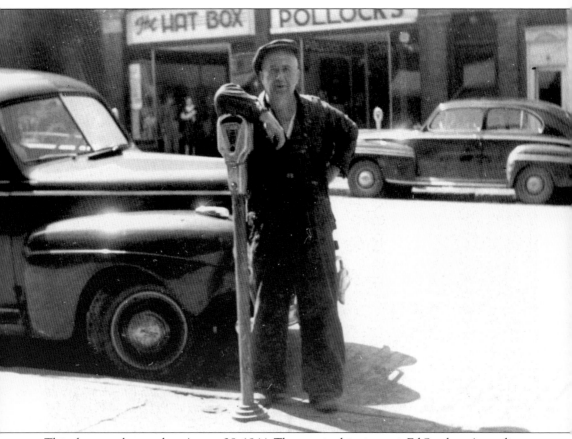

This photograph was taken August 28, 1944. The man in this picture is Ed Sarchet. According to a Cambridge directory of the 1940s, Ed Sarchet was a local plumber. Behind Sarchet is Pollock's Jewelry Store at 849 Wheeling Avenue. The Hat Box, also visible behind him, may be a part of Rose's Department Store, which was located in the area.

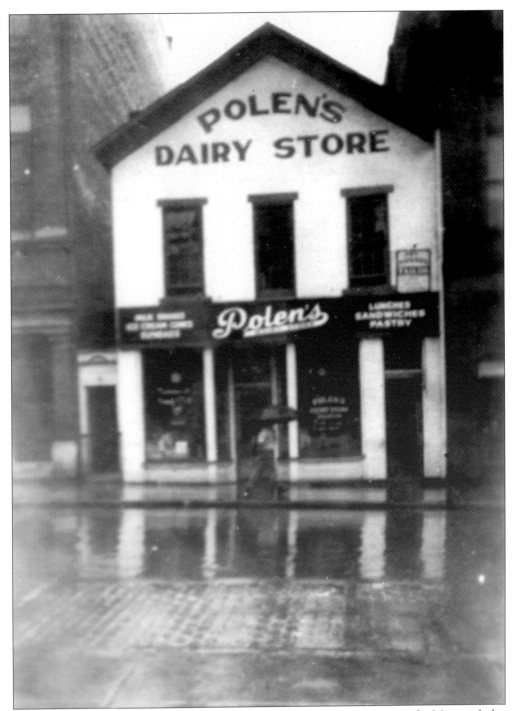

Polen's Dairy was a small restaurant located at 724 Wheeling Avenue, next to the Masonic lodge and J. J. Newberry's five and dime store. Chester Polen would treat his fellow lodge members to ice cream after lodge meetings. The Masonic lodge purchased Polen's Dairy sometime between 1948 and 1951. The lodge was just to the left of the Pole building at 730 Wheeling Avenue and rented out its lower story to the five and dime store.

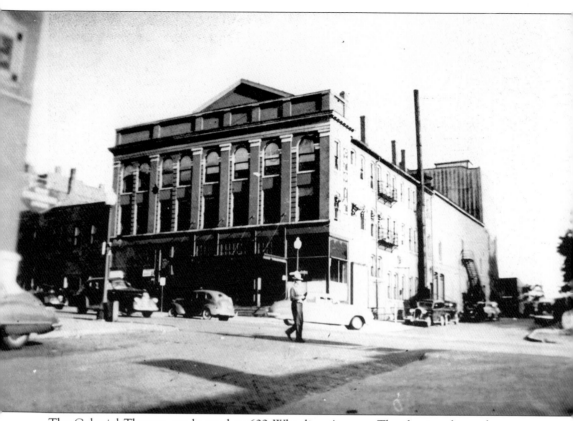

The Colonial Theater was located at 602 Wheeling Avenue. The theater changed managers several times before the address at 602 was listed as a vacant lot in 1942. Managers included the Hammond Brothers, 1910; C. E. Hammond, 1916; T. C. Weber, 1924–1926; Fred Johnson, 1929; and Gray Huffman from 1938 to its end.

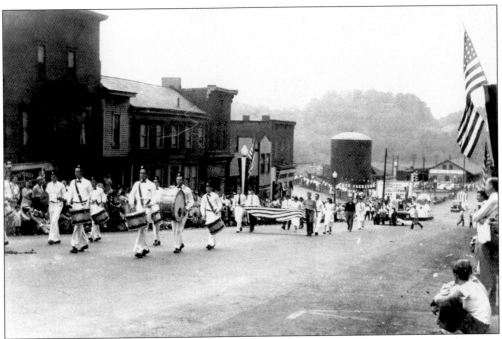

Wheeling Avenue has been the location of many annual and anniversary parades over the years. A corps of drummers keeps the beat in the 1948 sesquicentennial parade as the anticipation of the crowd builds.

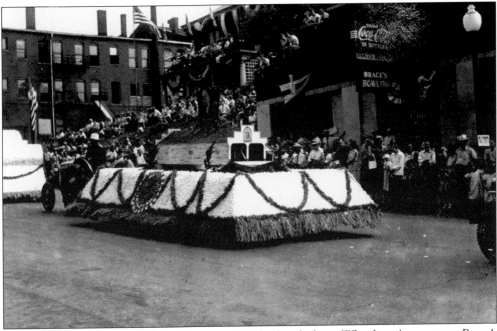

A float memorializing the old double covered bridge heads down Wheeling Avenue past Brace's bowling alley. The crowd was so large it was a standing- (or perching-) room-only affair.

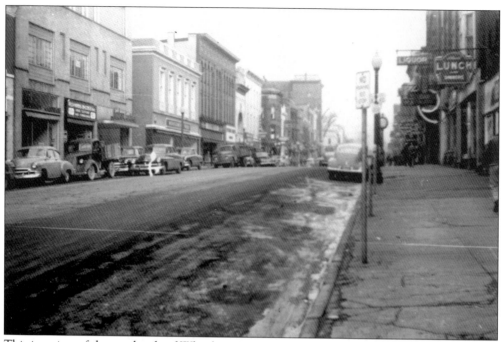

This is a view of the north side of Wheeling Avenue, looking east, in 1955.

This is a glimpse of the west end of Wheeling Avenue, the Berwick block, on September 9, 1949.

This is the north side of Wheeling Avenue in 1951, in a view looking west from Sixth Street to Fifth Street. Starting at the top of the hill, the businesses pictured are the Cambridge News Company at 551 Wheeling Avenue, the motor vehicle license bureau at 549 Wheeling, Ohio Billiards at 545 Wheeling, Milfair Linoleum occupying 537–539 Wheeling, Simon A. Cut Rate drugstore at 533 Wheeling, A&E Carry Out: Wine and Beer at 527 Wheeling, the LaSalle Restaurant at 517 Wheeling, and at 515 Wheeling, the State Hotel owned by Margaret Meanor.

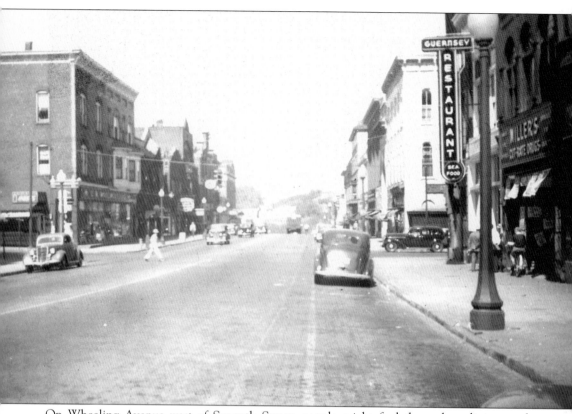

On Wheeling Avenue west of Seventh Street, people might find themselves dining at the Guernsey Dairy Lunch. In 1952, this establishment at 705 Wheeling was run by J. G. and A. J. Nicholakis. Inside one might step up to the counter or be seated at a booth. After lunch, an errand could be run next door to fill a prescription. Located next to the Guernsey Dairy at 709 Wheeling, Miller's Cut Rate Drugs was managed by D. L. Willis.

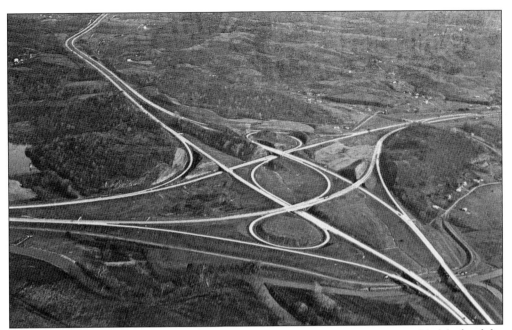

Just outside Cambridge is the cloverleaf where Interstate 77 meets Interstate 70. Much of the traffic on the National Road has been diverted by these busy highways, and Cambridge is no longer the mile marker that it once was. However, the highways have brought Cambridge the title "Crossroads of America" and continue to bring business to the area.

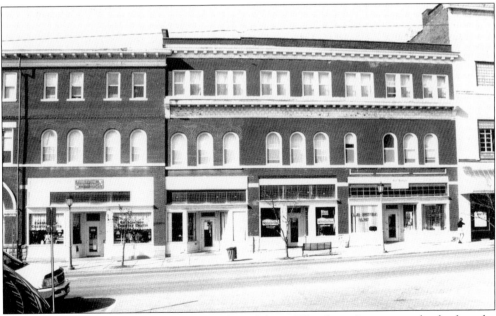

This modern photograph provides an idea of how Wheeling Avenue evolved after the interstates were built. The old buildings still exist, but the businesses have changed. Rather than a general store or hardware, the buildings house Cobblestone Country Crafts, American Family Insurance, and Hair Hunters Salon. Another major change is the sidewalks; they are no longer brick but cement.

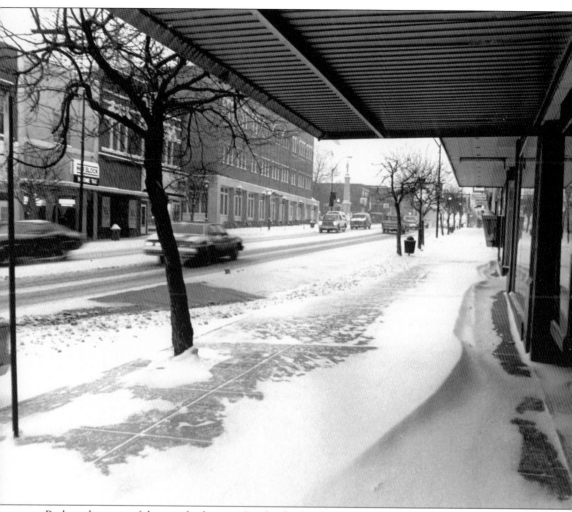

Perhaps because of the new highways, Cambridge has been able to retain its charm as a National Road town. The historic buildings are quaint reminders of an important past and hold an escape from the fast-paced life the interstates represent. Today visitors can stop into the Potter Davis building for a hot cup of coffee and browse for books, toys, and unique gifts.

Two

CAMBRIDGE AT WORK

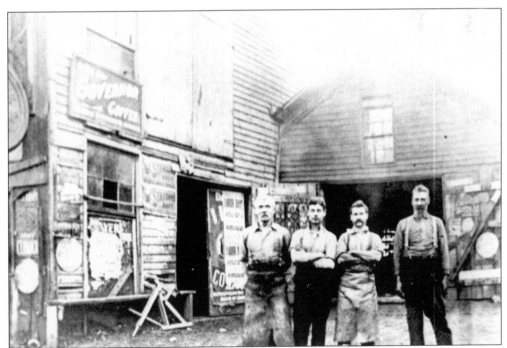

Four local blacksmiths step away from the coals for a moment to pose for this late-19th century photograph. With the arrival of new modes of transportation and new technologies in the 20th century, blacksmith shops would soon fade away.

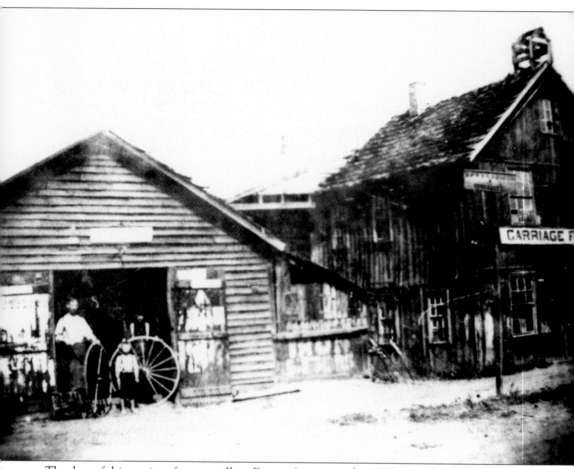

The days of this carriage factory, still on Dewey Avenue in the 1880s, would soon be numbered. With the arrival of the automobile and truck, the streetcar and interurban, the horse and cart would soon disappear.

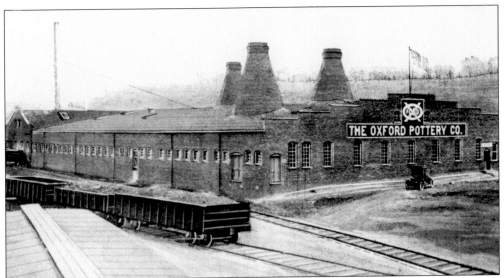

The pottery industry is one of oldest in Guernsey County. Oxford Pottery, later known as Universal Pottery, was one of the city's most significant producers of earthenware. On December 23, 1913, Oxford's founders purchased land between Burgess and Marquand Avenues. The pottery was incorporated on February 2, 1914. Later, under the name Universal Pottery, it grew to be one of the nation's largest potteries, employing between 550 and 600 people at its peak. Unable to compete with more cheaply produced imported pottery, it closed its doors in the 1960s. The images on the following pages date from the 1920s.

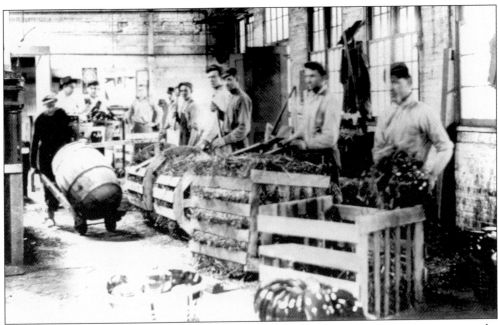

The men who worked on the floor of the packing room were always busy preparing pottery to be shipped. Pottery fired in Cambridge found its way into the homes of people across the nation.

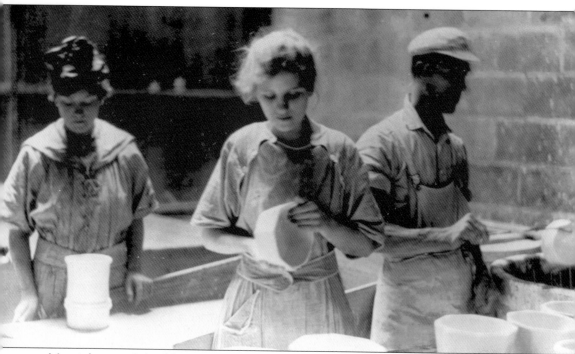

Most jobs were defined by gender in the early 20th century, although men and women worked side-by-side in the refining room of the pottery. Early-20th century labor laws often extended protections to women, considered the "weaker" sex, which were not extended to men. Nine-hour workdays for women and prohibitions on certain types of physical labor served to reinforce the tradition of gender separation in the work place and unequal wages.

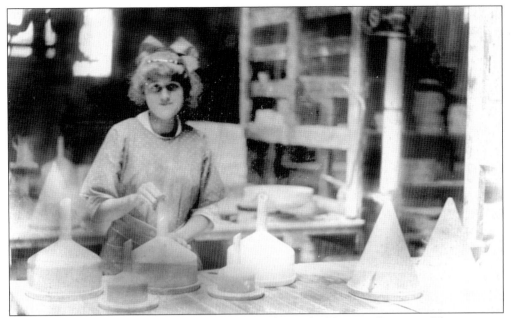

This woman is making funnels and colanders for the Oxford Pottery Company. The company also made a range of other products, including pedestals, umbrella stands, jardinieres, cuspidors, steins, and tankards.

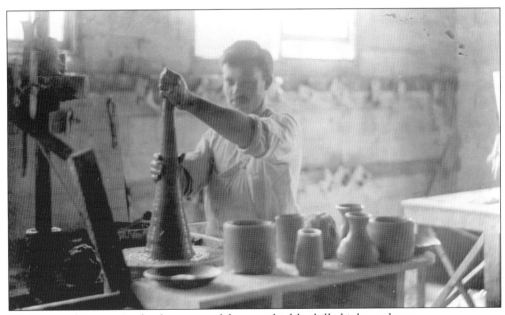

Working at the potter's wheel was one of the most highly skilled jobs at the pottery.

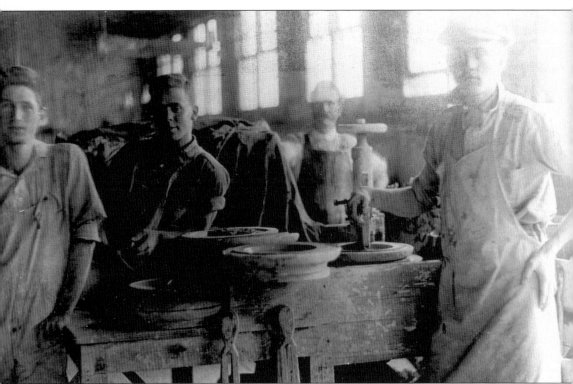

Four men take a break to pose for this photograph. The slight smiles on their faces suggest a pride in their work. The company's advertising slogan proclaimed that "One hour's experience with 'Oxfordware' means a life-long Friendship." The floor of the Oxford Pottery encompassed about two-thirds of an acre.

Cambridge was a logical location for the development of a national pottery industry because of the abundance of easily accessible clay in the region. The going rate for clay in the 1920s was about 75¢ a ton. In 1916, the pottery received a patent for the Odorless Oxford Water Seal—a brown and white lined vessel that was hermetically sealed and used only a small amount of water for cooking.

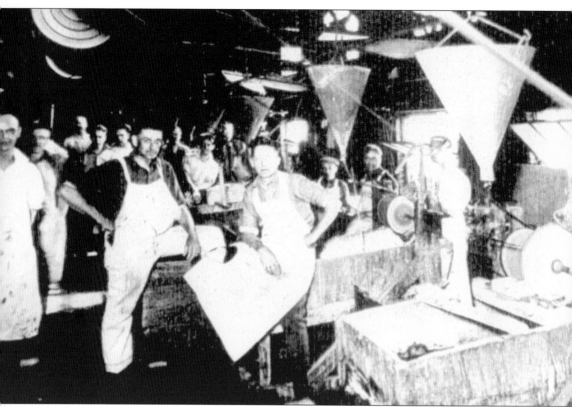

The Cambridge Glass factory was founded by Arthur J. Bennet of New York City, who came to the Midwest looking for a place to build his glass factory. He chose Cambridge because it was near the natural gas fields of West Virginia and the sand beds of eastern Ohio. The Cambridge *Daily Jeffersonian* heralded the arrival of Cambridge Glass, attributing the decision to locate here as a result of the region's natural resources, but also claimed it was due to Cambridge's reputation of having relatively few "labor difficulties." The *Jeffersonian* concluded, "Let our citizens now appreciate the fact that this means a largely increased population, and that it will be in evidence at the time of the fall fire at the plant." More houses should be built at once, the paper warned; "we must take care of these new citizens." Despite this optimism, population growth for the county in the next decade was modest. The men in this picture are working in the cutting department.

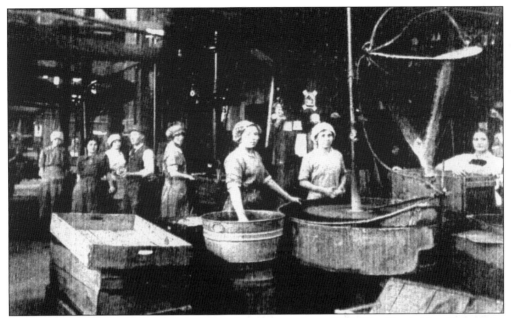

The factory opened in May 1902 and closed its doors in June 1954. The Cambridge Glass plant produced Nearcut Glassware, an affordable molded glass product designed to look more like expensive cut crystal. An all-female crew is working in the grinding department. Many of the jobs in the glass industry were separated by gender.

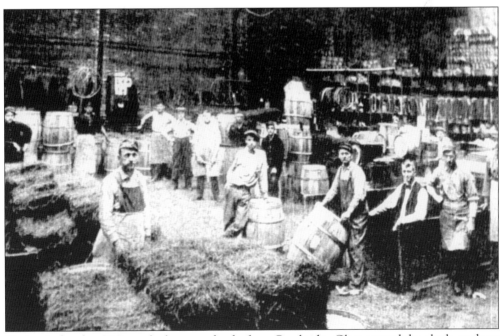

During its heyday, 700 people drew paychecks from Cambridge Glass around the clock on three shifts. The plant was razed in October 1990, after an effort to save and restore the buildings failed. The men in this photograph are working in the packing room.

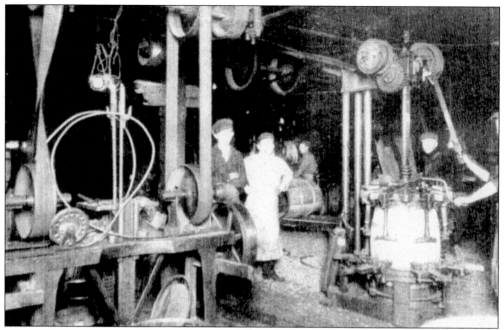

Cambridge Glass employed its own barrel makers for packing and shipping glass.

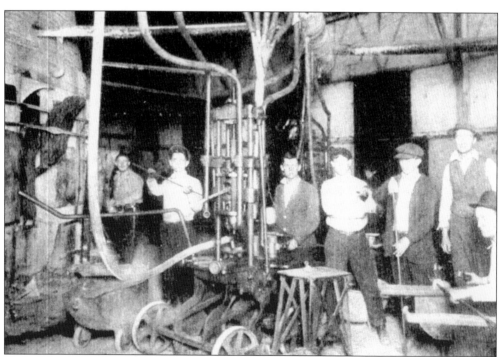

These men are busy pressing oil bottles at the Cambridge Glass factory around 1930.

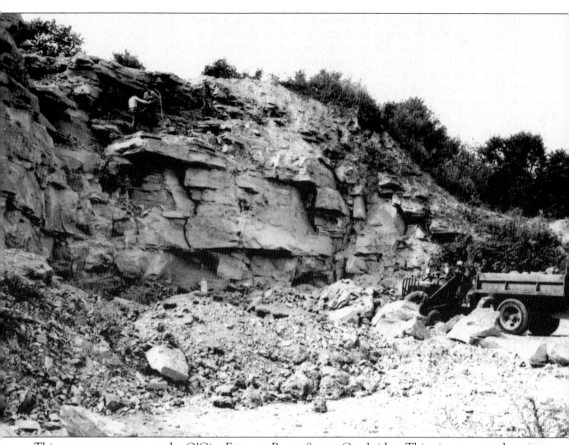

This stone quarry was on the O'Gier Farm on Route 8 near Cambridge. This picture was taken around 1950.

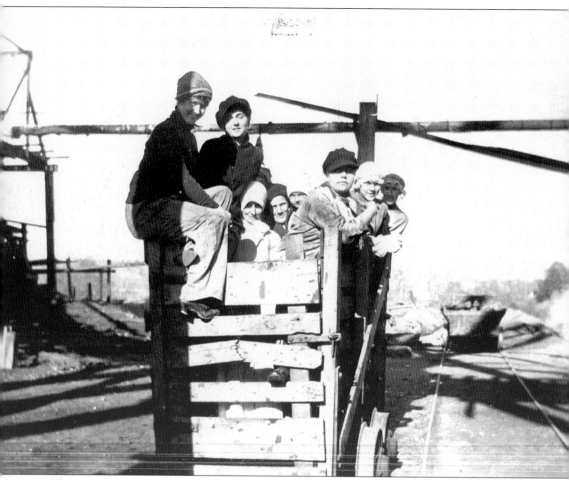

These young women covered their heads in anticipation of their field trip into one of the shafts of the Cambridge Collieries coal mine. This souvenir picture had these words written on the back: "This one was taken just before we went into the mine. Think you can see me with the lace cap on. Notice Miss Hughes sitting up on end of car in front. Lela, Lillian, Bess and Irma and Neva all had overall suits on." Four names are listed: Irma Hughes, Lela Bonom, Lillian Healey, and Olive Cameron.

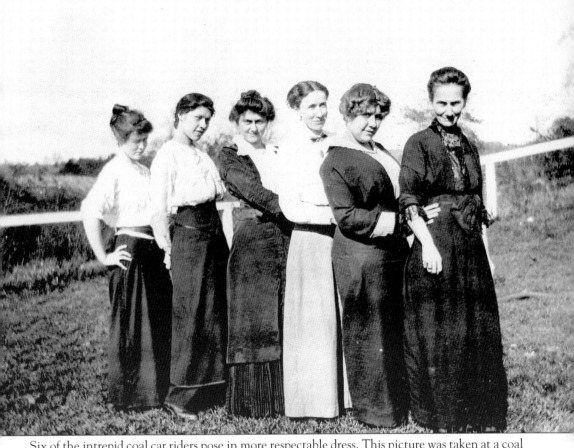

Six of the intrepid coal car riders pose in more respectable dress. This picture was taken at a coal company picnic. Pictured are, from left to right, Lela Bonom, Lillian Healey, Olive Cameron, Irma Hughes, Neva Bonom, and Mrs. Healey.

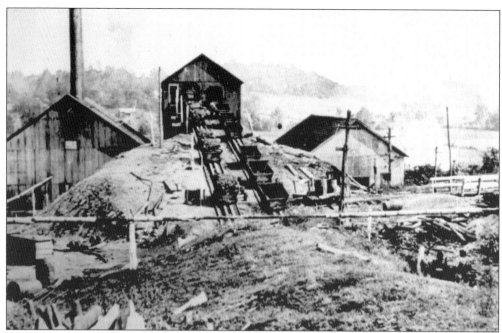

Underground coal mining was a very important part of the local economy in the late 19th century and through the first half of the 20th century. Underground mines dotted the landscape south of the city. The Midway mine was one of those closer to town, located out by the old Cambridge airport.

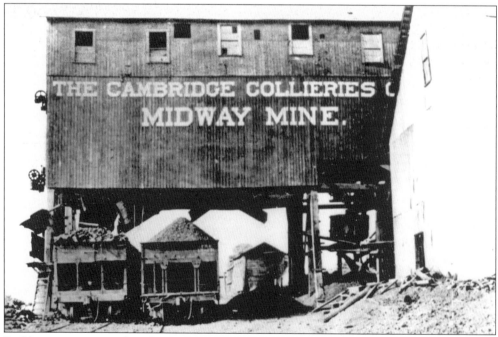

Rail lines were essential to the mining operations, primarily to carry away the coal but also to deliver miners to work and back home. Today a tourist train takes passengers along one of these lines from Byesville to Derwent, past the sites of many of the old mines.

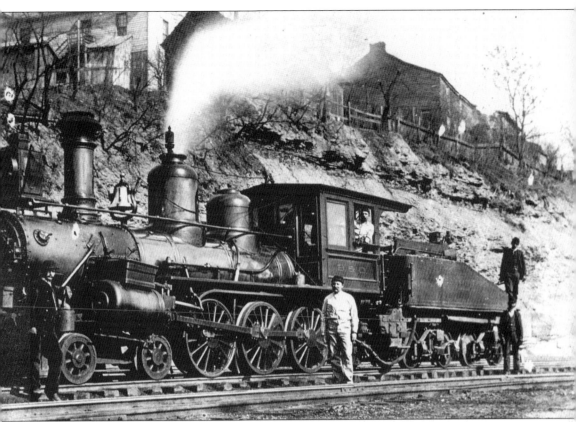

The B&O Railroad was perhaps as important in the development of Cambridge as the Old National Road. Its tracks run just south of Turner Avenue, below the bluff. Here an old steam train idles just below Sixth Street.

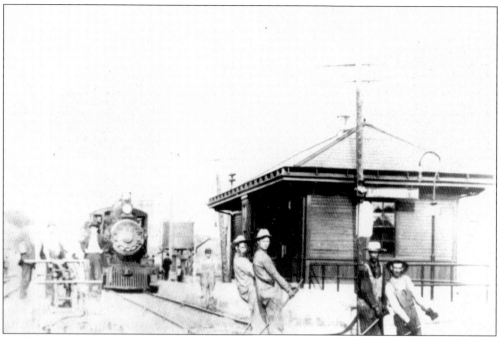

Rail lines radiated out from Cambridge in several directions. A major line headed east through Lore City, an early farming community in close proximity to the mines.

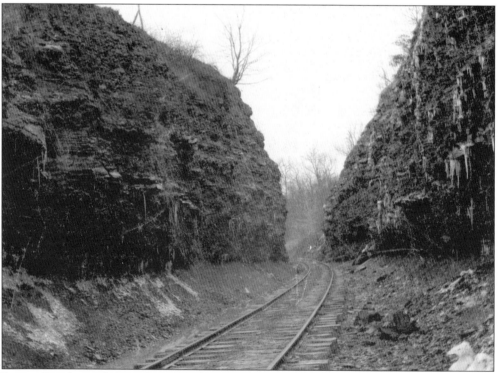

Pigeon Gap, located along the Pennsylvania Railroad, lies two miles north of Cambridge.

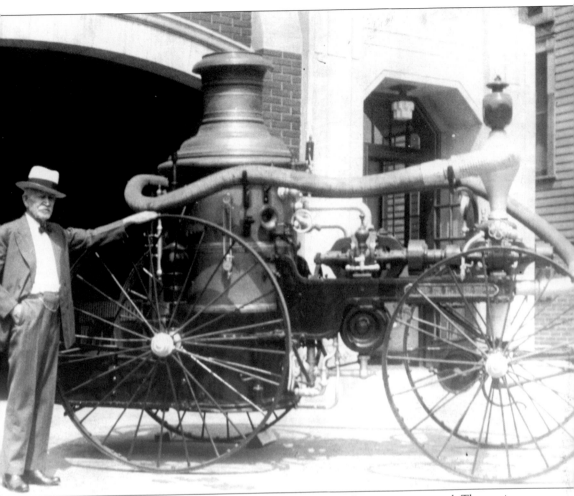

T. W. "Field" Scott was the fire chief during the first 25 years this engine was used. The engine cost $6,500 and was pulled by hand. A source of much amusement, the engine was pulled down to Wills Creek, where it could pump limitless amounts of water and shoot it from its hose to entertain the public. It appeared at the head of many parades, and during periods of drought, it was used to water Main Street to keep the clouds of dust down.

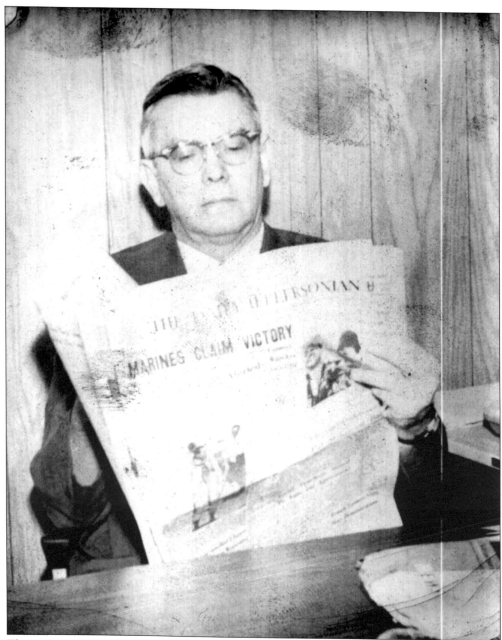

The newspaper now known as the *Daily Jeffersonian* started publication in (Old) Washington, Ohio, in 1824, under the name the *Washington Republican*. It was the first Democratic newspaper in the county. The paper was sold to P. B. Ankey in 1838 and was renamed the *Democratic Star*. In 1842, it was again sold to Dr. William Anderson and renamed the *Democratic Signal*. In 1844, Mr. Gill purchased it, moved it to Cambridge, and renamed it the *Jeffersonian*. In 1892, the newspaper became the *Daily Jeffersonian* that is known and read today. Pictured above is editor Robert W. Amos. He later became president of the *Daily Jeffersonian* and retired in 1978.

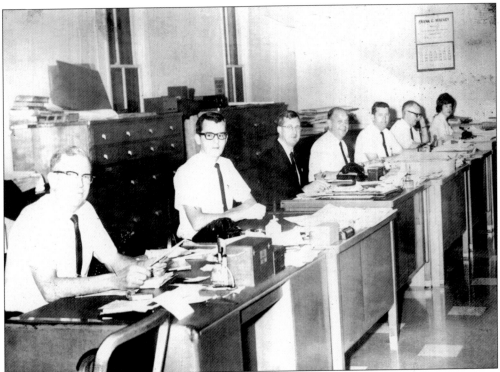

Here is the Display and Classified Advertising Department. From left to right are Victor Larrick (display manager), Neal Altland, Henry Fromont, Paul Anderson, Russell Patterson, Andy Smith (classified manager), and Clarice Mckee.

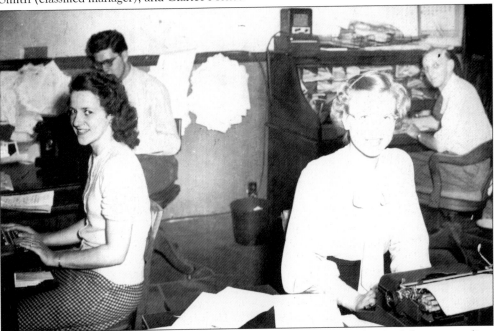

This is a view of the newsroom in the early 1950s. Pictured on the far left is wire editor Ernie Sheehan.

Here is the old printing room. This type of press is called a flatbed press. In 1955, the *Jeffersonian* updated to a Goss letterpress and again updated to an offset press with a color unit.

Three

CAMBRIDGE LIFE

One could find many young Cambridge men at Dick and Perkey's place when they were not at work.

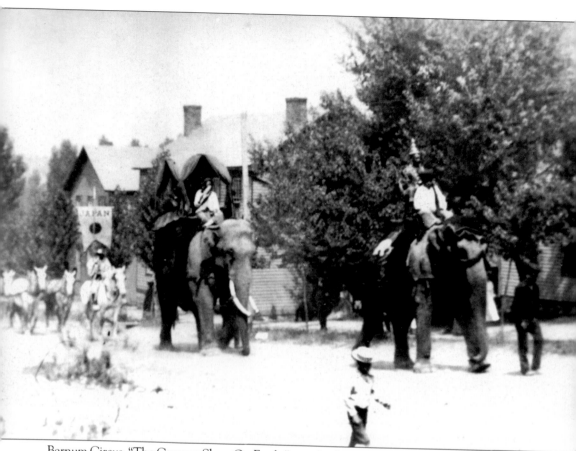

Barnum Circus, "The Greatest Show On Earth," parades down Seventh Avenue near Steubenville Avenue in 1887. The small boy in front of the elephants is David Carnes.

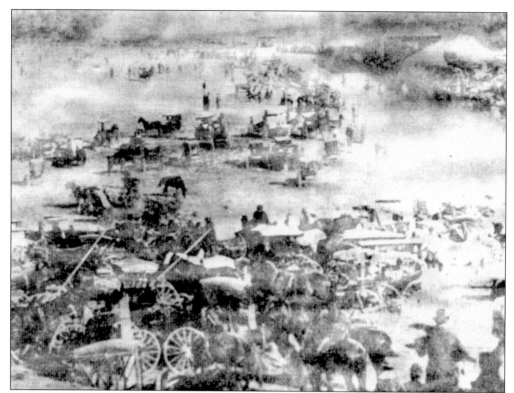

The Guernsey County Fair has been an annual tradition since 1847. The fairgrounds lie a few miles east of Cambridge in Old Washington. This image from September 27, 1900, gives a glimpse of the fair in the pre-automobile era. The Guernsey County Fair tradition continues to this day, held annually in the second week of September.

The Cambridge Hiawatha Club was a book club that gathered often to discuss literary works but was not averse to outdoor fun. Here members of the club gather at the Hiawatha Lake assembly in Mount Vernon in 1907.

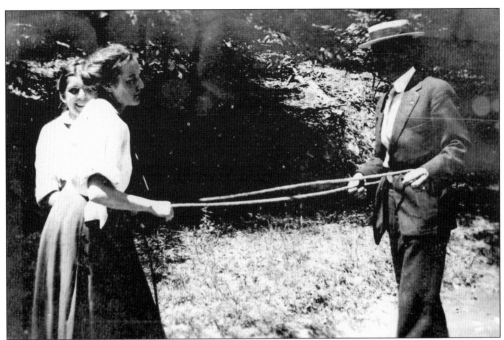

This young woman appears to have "captured" a young gentleman during a summertime frolic at Perry's Den.

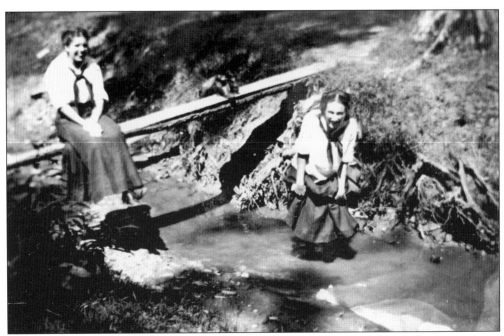

Two young women take off their shoes and cool their feet in a creek at Perry's Den

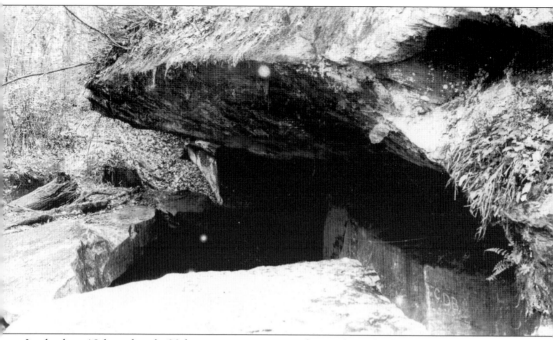

In the late 19th and early 20th centuries, many residents of Cambridge took an excursion to this location in southern Guernsey County, near the Noble county line. This place, known locally as Perry's Den, was a romantic rendezvous for lovers and a great place for a picnic. Early in the 20th century, it became an even more popular destination when a small amusement park was opened at the site. The location attracted visitors not just for its natural beauty but for the historic legends attributed to it. A local horse thief and counterfeiter, Walter G. Perry, allegedly used the location to hide his ill-gotten gains. One cavern was large enough to stable 20 stolen horses. Years later, one local claimed to have uncovered a hoard of counterfeit coins near Perry's home; another local legend suggests treasure is still buried near the den. Perry's Den is located in Spencer Township, about two miles east of Cumberland, on private land.

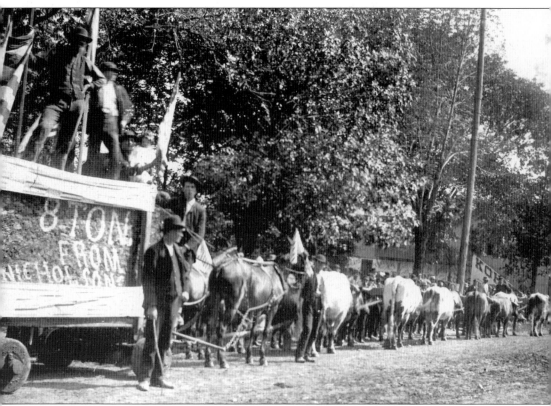

On August 21, 1886, the first miners' picnic was held in Cambridge. To commemorate the event, the Nicholson mine (two miles south of Cambridge) attempted to bring this mammoth lump of coal to Cambridge for the festivities. A special truck was made to carry the coal to Cambridge, but village officials would not allow the heavy load, pulled by 12 oxen and 6 mules, to cross the upper Wills Creek Bridge, for fear it would buckle. Taking the long way around down Georgetown and Dewey Avenues, they planned to cross at the old double covered bridge. Still, officials were concerned that the combined weight of the coal and the animals was too great, and so the load had to be pulled across the bridge on long cables, ensuring the livestock and coal were not crossing at the same time. As the cart climbed the hill into town on Wheeling Avenue, the wheels and axles caught fire from the extreme friction. The cart made it to the courthouse square before it was determined that the cart was too damaged to carry it to the picnic site. A local clothier, Otto Thalheimer, offered the miners $100 for the mammoth lump, and the miners used the payment to purchase instruments for the miner's band. Thalheimer kept the lump on display in front of his store until the following winter, when he broke it up and gave pieces to the town's neediest residents.

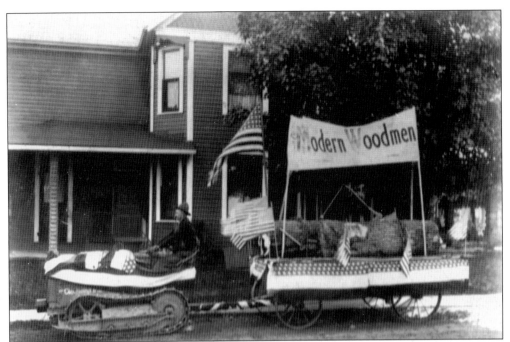

Old Home Week was the town's homecoming celebration to welcome all natives of Cambridge home for a visit. This picture of the Modern Woodmen's float dates from 1913.

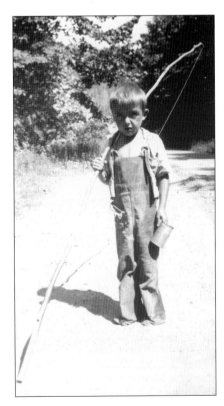

A young boy gets ready to drop a line near Marquand Mills on Wills Creek in 1945. Fishing has always been a cheap and rewarding form of recreation that can be enjoyed by young and old alike.

75

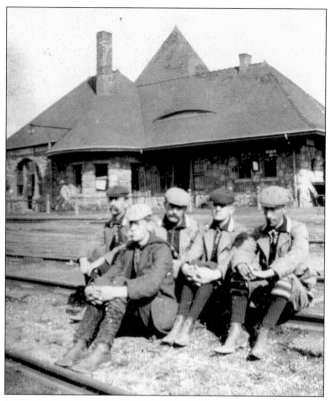

Cycling was a popular pastime at the beginning of the 20th century, and national recreational riders like the League of American Wheelmen campaigned for improved roads to better enjoy their sport. A group of Cambridge men took off on the adventure of a lifetime when they embarked on a bicycle trip to Ontario, Canada, in the summer of 1904. The men included Frank Arnold, Jake McCullough, Will Kirkpatrick, and J. Atkins. The Cambridge wheelmen are seen riding through the streets of Detroit, Michigan, below.

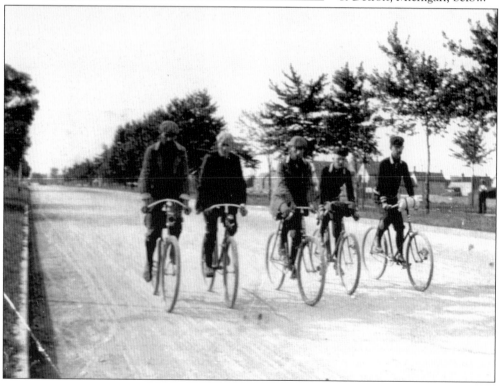

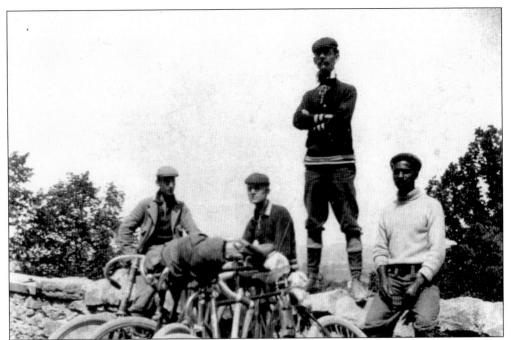

Here the Cambridge wheelmen are shown arriving at their final destination in Ontario, Canada, on August 4, 1904.

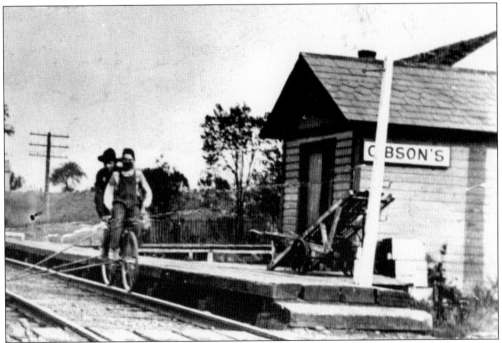

These two men have found riding the rails a unique alternative to roads. Gibson's station lies a few miles east of Cambridge. This stretch of old railway bed is currently being developed into a local rail trail where families can enjoy a bike ride or a hike without fear of trains.

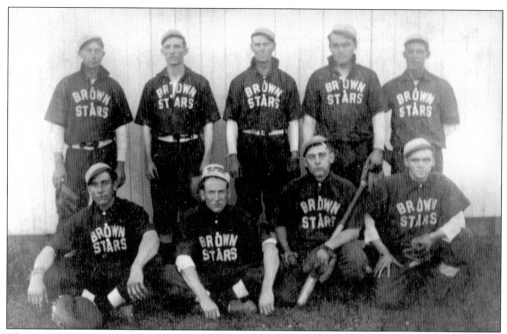

The Brown Stars were a local baseball team that played neighboring cities' teams in a small-town recreational league. This team picture was taken around 1890 and includes Lew Pierce, located on the left in the top row.

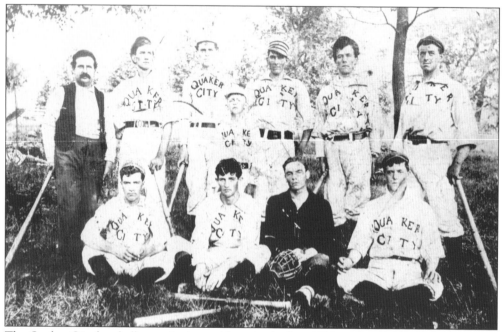

The Quaker City baseball team is pictured here in the late 1890s.

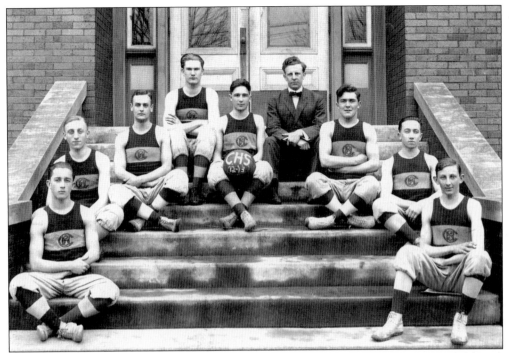

The 1912–1913 Cambridge High School basketball team had a record of 7 wins and 5 losses. Among those pictured here are Harry Ryles, George Ritter, Burt Addison, Bill Meredith, Sidney Jenkins, coach Henry Pine, Paul Salmons, and Ernest Sheckman.

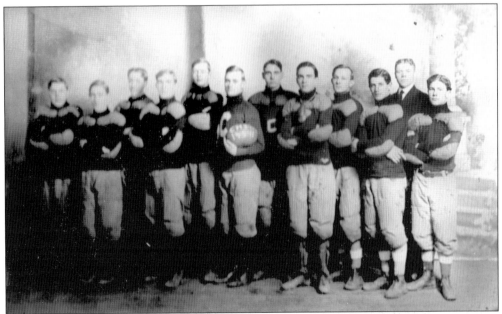

The Cambridge High School football team of 1907 is pictured here. From left to right are Jack Vincent, Carl McMurray, Edward Cook, Fred Tribbie, Max Dilley, Harry Rigby, Edwin Thompson, James Baird, Ralph Dollison, Wilbur Orme, coach Hugh Smith, and Homer Smallwood.

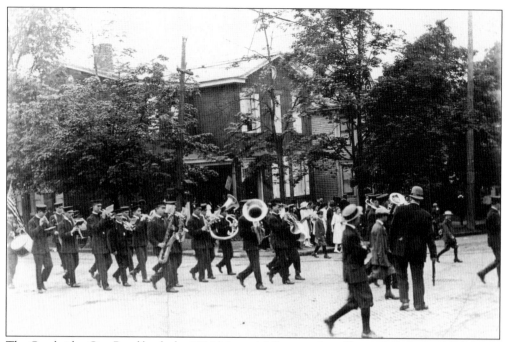

The Cambridge City Band leads the 1914 Memorial Day parade at Eleventh Street and Wheeling Avenue. The holiday was founded to remember those who gave their lives in the Civil War.

Cambridge boys drill in the 1914 Memorial Day parade. Four years later, some of these boys may have been fighting overseas.

Two local girls are playing a little game of leapfrog on August 19, 1926. The girl standing, despite having on a miniskirt, is also wearing knee-highs.

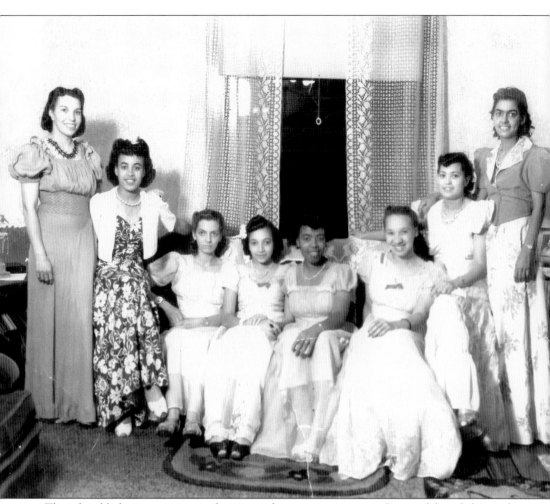

These local ladies are getting ready to attend a community event. Pictured from left to right are Georgie Melvin Quarles, Kathleen Betts, Vivian Marie Peterson Tolliver, Ellvan Betts, Wynona Goins, Evelyn Lee King, Marilee Betts, and Ruth Margaret Peterson Fultz.

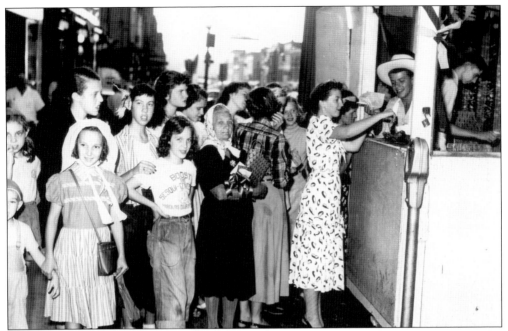

Ruth Stoffer, the 1948 sesquicentennial queen, buys a waffle from one of the many vendors who set up downtown. The festivities brought crowds of 15,000 or more downtown, where Slavs from the nearby coal communities, like the woman depicted in a babushka here, mingled with city residents.

Canoeing was a popular pastime in the 1940s but was not usually done in a pool. Some local boys demonstrate their righting and rescue skills at the municipal pool during the 1948 sesquicentennial festivities.

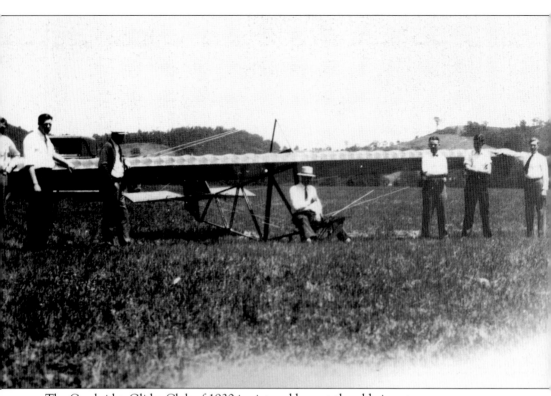

The Cambridge Glider Club of 1930 is pictured here at the old airport.

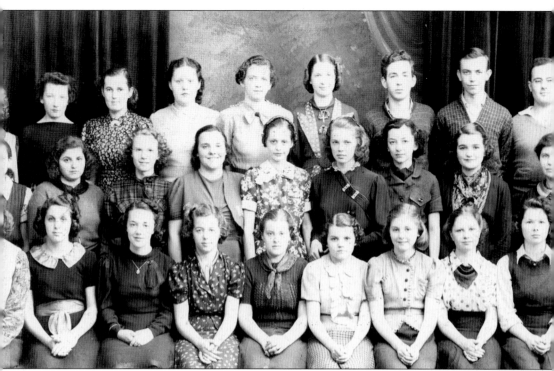

The Cambridge High School Whistling Chorus is seated for this picture. The chorus performed at local events, usually accompanying the performance of the Cambridge High School Singing Chorus. Janette McFarland, instructor, is in the middle row on the far right.

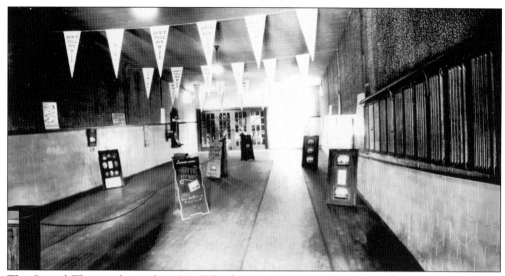

The Strand Theater, located at 640 Wheeling Avenue, is seen in this picture taken in 1927. The theater opened for the first time on November 24, 1915, with Graustark pictures starring Francis X. Bushman and Beverly Bayne. No wood was used in the production of the theater, allowing it to advertise as "near fireproof." The new building's cost was $50,000, including the $10,000 pipe organ. It was built entirely of bricks, cement, and structural iron. At the time of its opening, experts pronounced that the Strand Theater was the most complete theater in eastern Ohio. The main auditorium had a seating capacity of 550, while in the two balconies, there were seats for 250 more.

This is a street view of the Strand Theater.

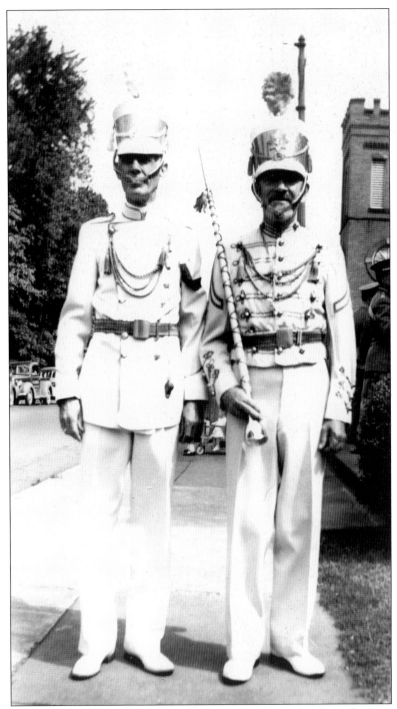

Commanders of the Cambridge City Band stop for a picture in a local parade. Peter Sheehan, the director, is on the left.

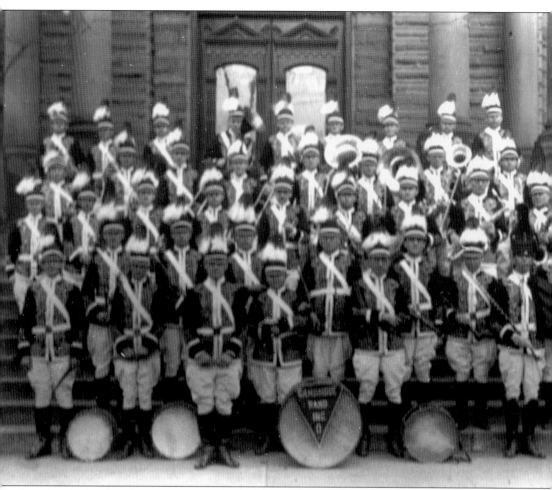

Decked out in their concert regalia, the 1923 edition of the Cambridge City Band poses for a picture on the courthouse steps.

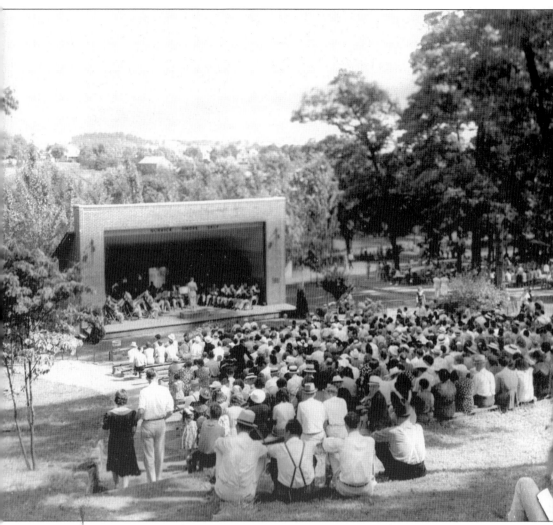

The 1940 Cambridge City Band performs at Tuscarawas Park in New Philadelphia, Ohio, in front of a very large crowd of spectators. The director of the band is Peter Sheehan.

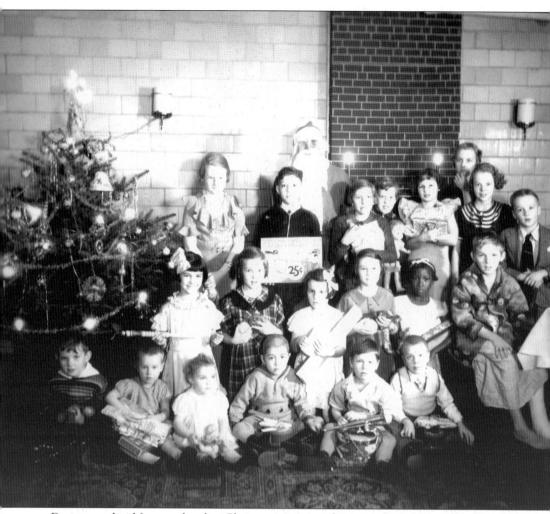

During a typhoid fever outbreak, a Christmas party was thrown at Swan Hospital on December 22, 1935, for children who were patients and victims of the disease.

The Cambridge Country Club was organized in 1905 and incorporated in 1926. W. L. Orme was the first president of the country club. This picture was taken on May 8, 1938, in a view looking west from the country club porch at the golf course. In the background of the picture, Route 209 South can be seen.

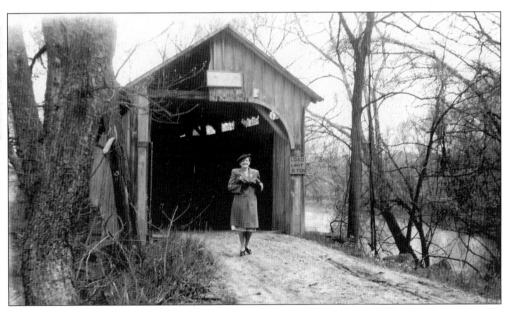

Mrs. H. R. Ayers is pictured here standing at Kennedy Bridge over Wills Creek on May 27, 1946. Kennedy Bridge was located at Liberty Township Road 209 about seven miles north of Cambridge. The bridge was built in 1855 by John A. Wharton for $878.25 and named for Andrew Kennedy. At the time, Kennedy Bridge was the only two-span covered bridge in the county and the longest at 102 feet. Due to the deteriorated condition of the bridge, in 1962, county officials ordered for the 107-year-old bridge to be torn down and replaced with a safer modern bridge.

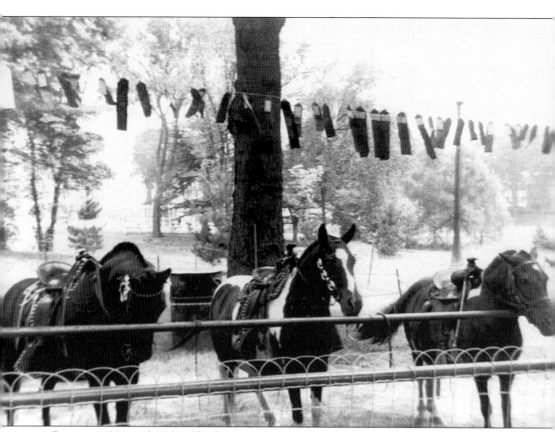

Between 1930 and 1950, Charles Patterson and Mr. Collart could be found in the city park offering rides to small children on these prize-winning horses.

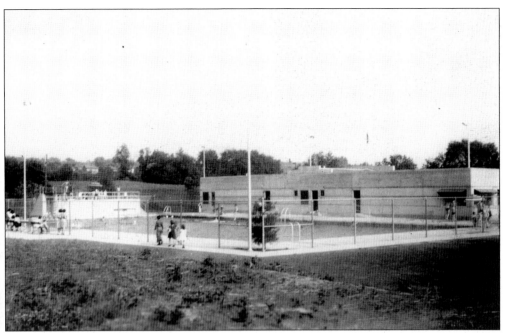

Some local citizens are enjoying the warm July day in 1941 at the municipal swimming pool.

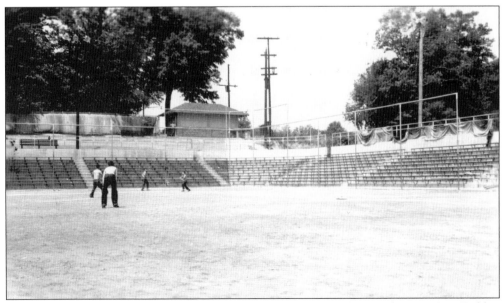

A couple of young boys are practicing their baseball skills, as seen here at the Don Coss Field at the city park in Cambridge in 1947.

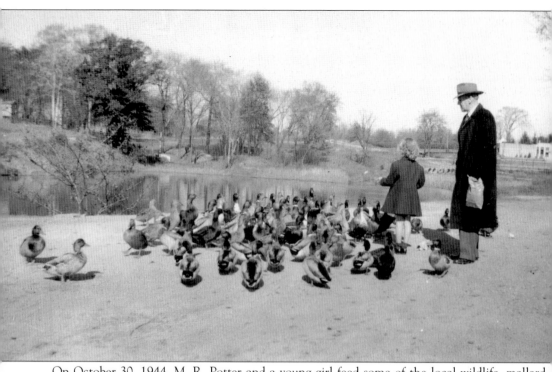

On October 30, 1944, M. R. Potter and a young girl feed some of the local wildlife, mallard ducks, at the city pond.

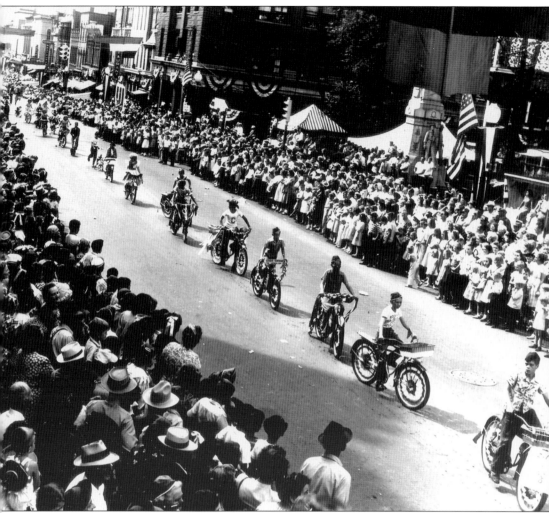

The local boys of Cambridge get into the patriotic spirit of the 1948 sesquicentennial parade festivities as they ride through downtown streets. A weeklong celebration of Cambridge's 150th birthday occurred Labor Day week in 1948. Daily parades and a pageant at the city park were highlights of the festival. The pageant told the story of Cambridge in 17 historical episodes, from early Native American life to pioneer stories, the story of the National Road, and a "ballet of industry" to celebrate the contributions of important local industries like coal, glass, and pottery.

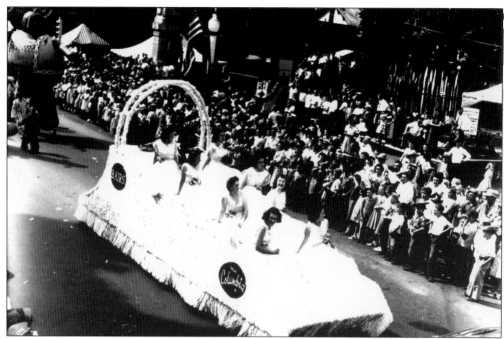

The nominees for the Bair's Miss Columbia competition parade through the streets of downtown Cambridge during the 1948 sesquicentennial parade. Bair's was a local furniture business.

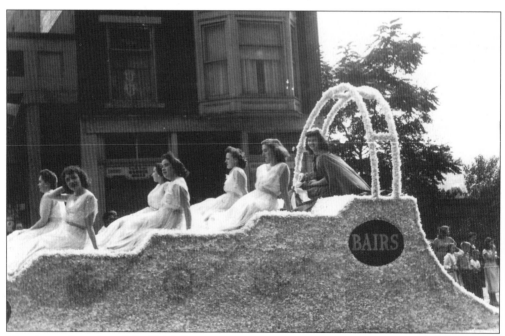

Here is another view of the Bair's float.

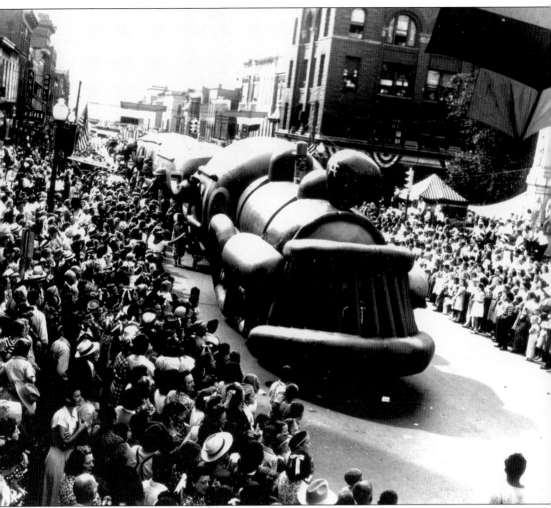

On Saturday of sesquicentennial week, the governor visited and a "Grand Historical Parade" recounted the history of the county. It was appropriate for the sesquicentennial parade to include this balloon train, as the decision to run the B&O Railroad through Cambridge was critical to its early growth. The first passenger train arrived in Cambridge in 1854.

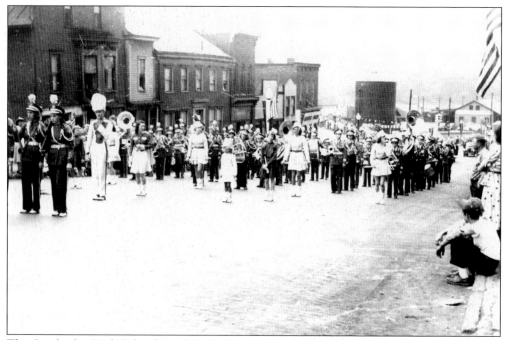

The Cambridge High School Band leads the sesquicentennial parade down Wheeling Avenue.

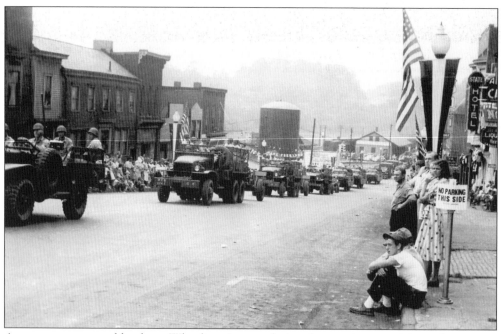

An army convoy rumbles down Wheeling Avenue during the sesquicentennial parade.

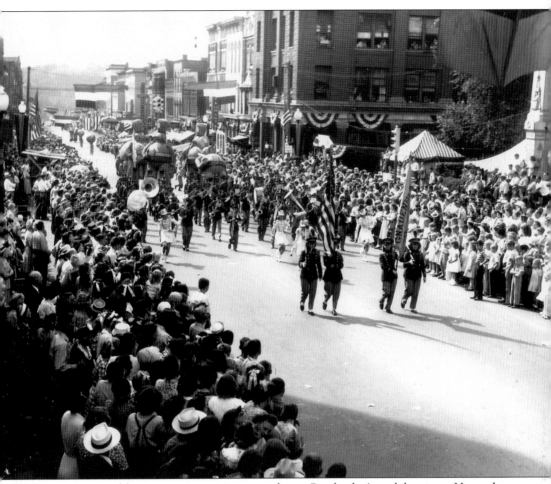

Citizens from neighboring communities joined in Cambridge's celebration. Here the Gnadenhutten High School Band marches by the courthouse.

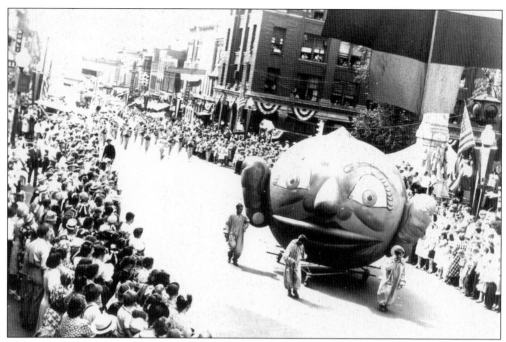

This remarkable balloon face, guided by a trio of clowns, was just one of the unique features of the parade that made it a true spectacle for the crowds.

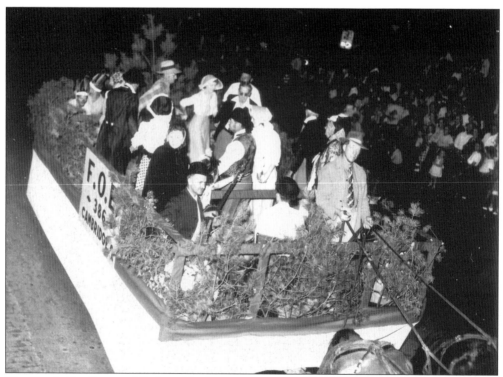

The Cambridge Fraternal Order of Eagles sesquicentennial float is seen here.

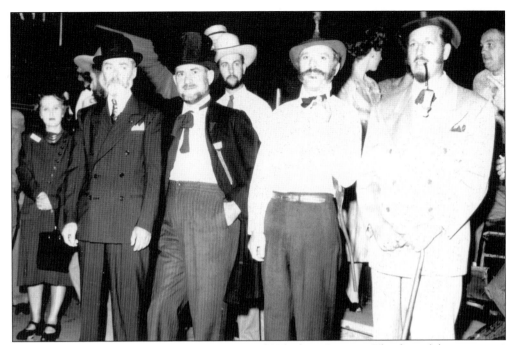

This photograph is of the 1948 Sesquicentennial Whiskers Contest. The first of three contests are pictured here.

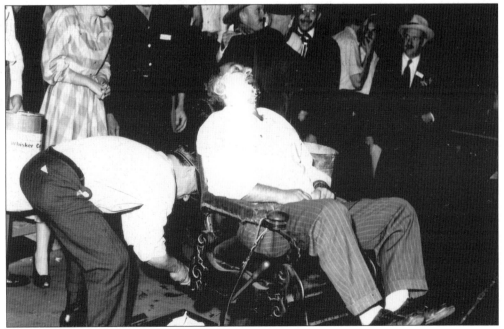

One of the whisker contest's winners gets a free public shave.

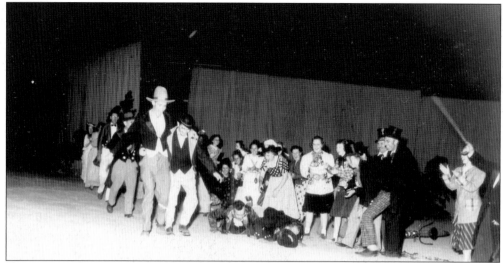

Citizens are taking part in the 1948 sesquicentennial three-legged race.

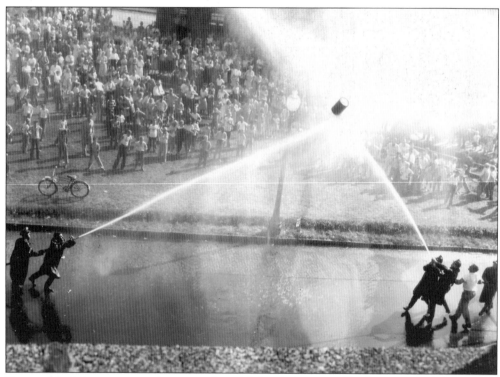

Teams of firefighters compete in a water barrel fight while a crowd looks on.

After winning a landslide electoral victory in 1946, Republican governor Thomas J. Herbert (center) joins in on the celebration.

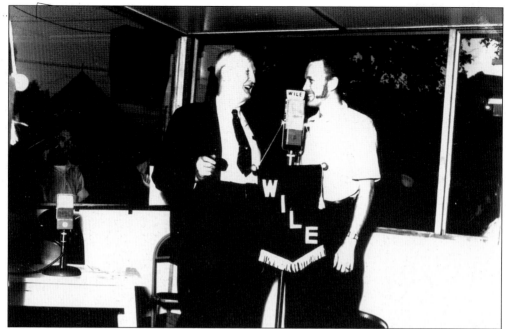

After his playing days with Casey's Colts, Cambridge's amateur baseball team, and his glorious and successful career in major-league baseball, Cy Young returned home to Ohio and would occasionally engage in local Cambridge radio talk shows on WILE. Fans can visit Cy Young's grave near his childhood home, Peoli, north of Cambridge.

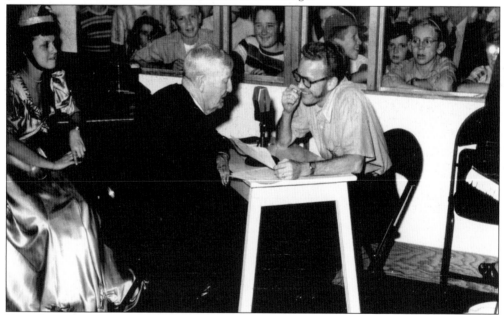

Eager fans are pressed up against the WILE studio window to catch a glimpse of this major-league legend with local roots. When asked by a reporter where he got his remarkable pitching ability, Young recalled his youth in Guernsey County and explained, "All us Youngs could throw. I used to kill squirrels with a stone when I was a kid, and my granddad once killed a turkey buzzard on the fly with a rock."

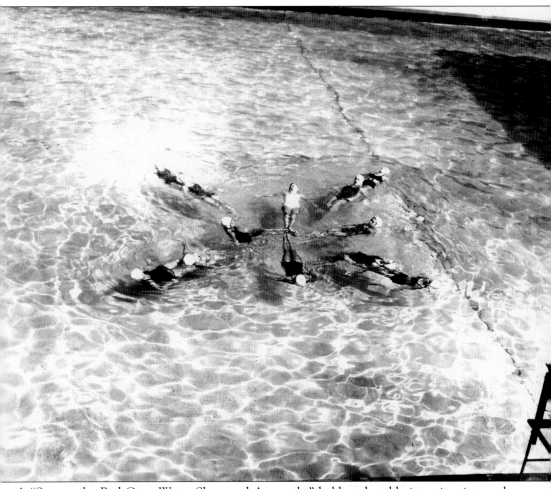

A "Spectacular Red Cross Water Show and Aquacade," held at the old city swimming pool, was the highlight of the Thursday program during sesquicentennial week. Cambridge's finest synchronized swimmers perform an aquatic flower.

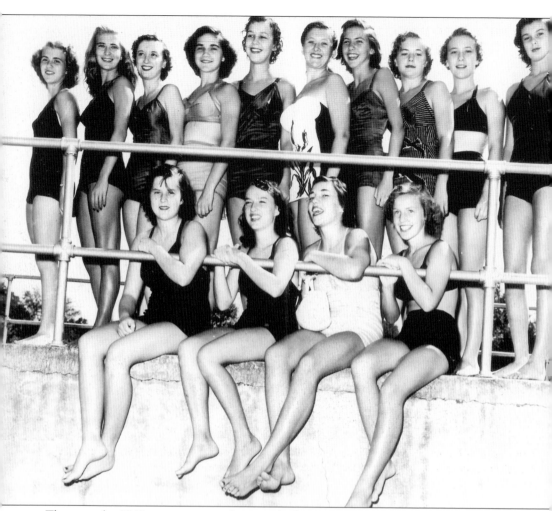

These are the 1948 sesquicentennial aquatic bathing girls.

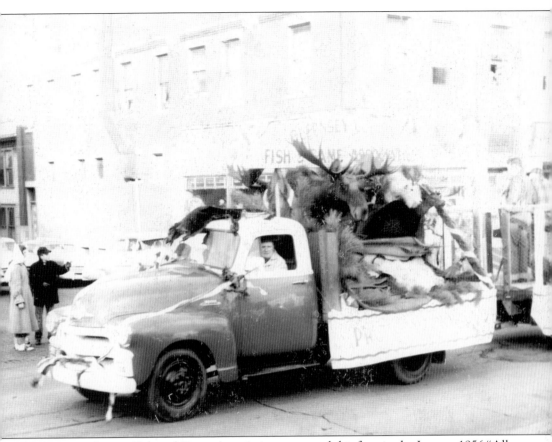

The Guernsey County Fish and Game Association sponsored this float in the January 1956 "All American City" parade. "Protect Our Wildlife" was their theme.

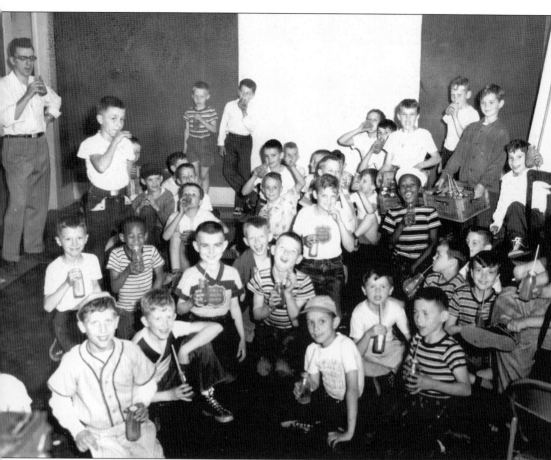

Some boys enjoy a drink break at the YMCA in May 1951. The idea for a Cambridge YMCA was hatched by some local parents in the spring of 1945. With an annual budget of $900 and pledges from local citizens groups, the Cambridge YMCA was established at 917 Wheeling Avenue. After several moves, the YMCA purchased the Gross Mansion in 1958. On April 5, 1964, they broke ground on a new gymnasium and pool. Generations of Cambridgians have learned to box, swim, tumble, fence, and play basketball and assorted other sports at the Cambridge YMCA. More than this, they have learned about kindness, civic duty, character, etiquette, fair play, and sharing. As the YMCA leadership moves forward on its development of new facilities for the 21st century, it carries on the legacy of those first Cambridge families who launched this dream a half century ago.

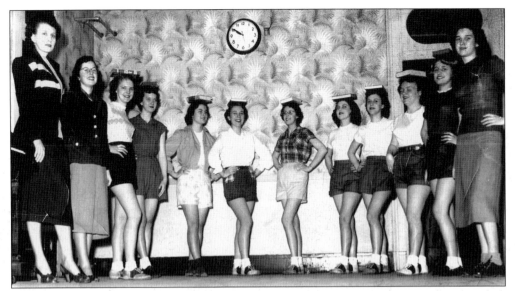

Shown in YMCA charm school in 1952 are (from left to right) an instructor, unidentified, Bonnie Makers, Delores Hamilton, Betty Tostenson, Jean Smith, Pat Hall, Jerry Myers, Sally Moss, Carol Wilson, Barbara Harrison, and Jan Schaub

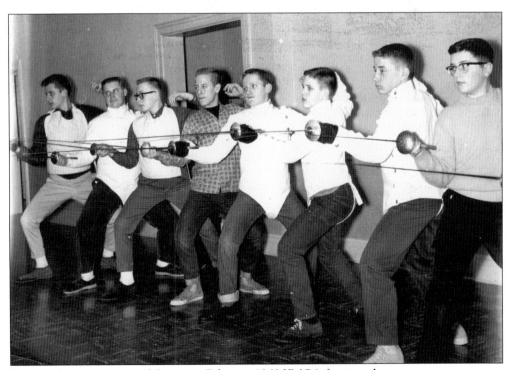

Students learn to parry and feint in a February 1960 YMCA fencing class.

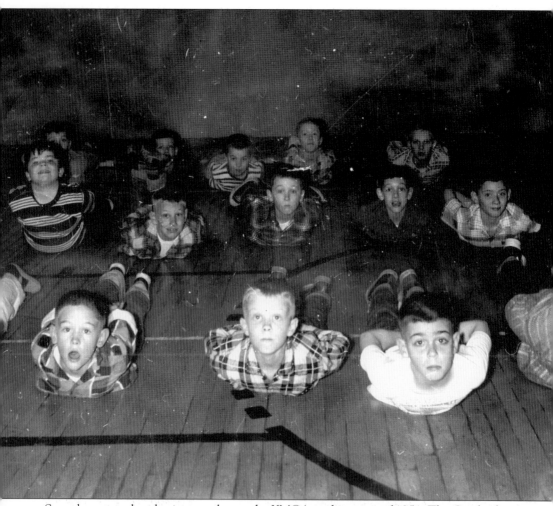

Some boys stretch to begin gym class at the YMCA in the spring of 1951. The Cambridge Area YMCA continues to help young people develop healthy minds and healthy bodies today.

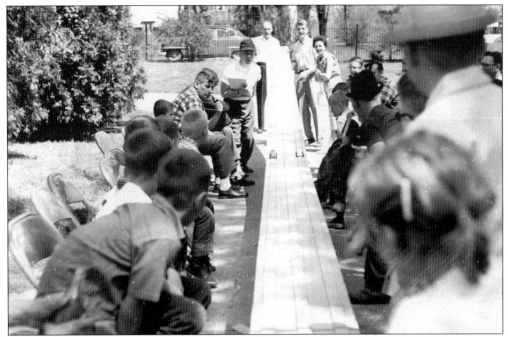

A crowd looks on as two boys compete in the YMCA Pinewood Derby in June 1959.

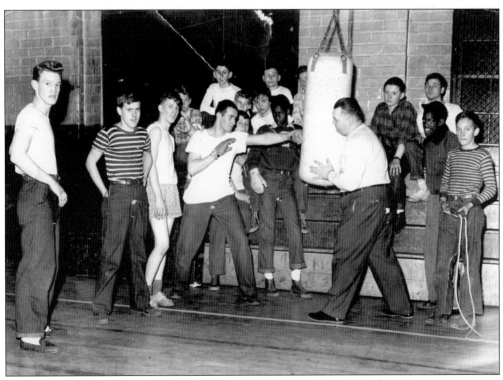

Local aspiring boxers hone their skills in a YMCA boxing class in March 1949.

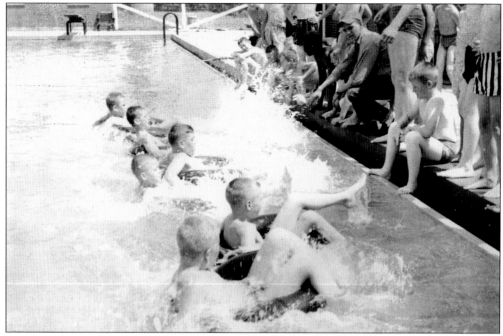

A group of young boys compete in an inner tube race at the YMCA day camp at the city pool in 1959.

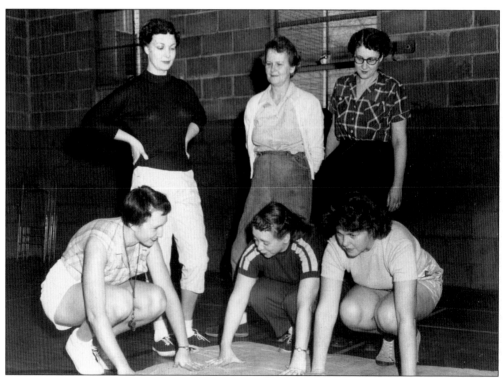

Shown here is the YMCA ladies' gym class in 1950.

Young ladies pose for the YMCA tourism program in 1955.

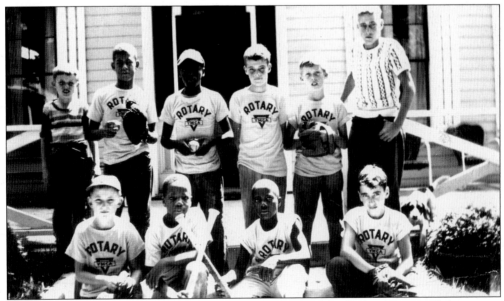

The 1950 YMCA baseball league champions were sponsored by the local Rotary Club.

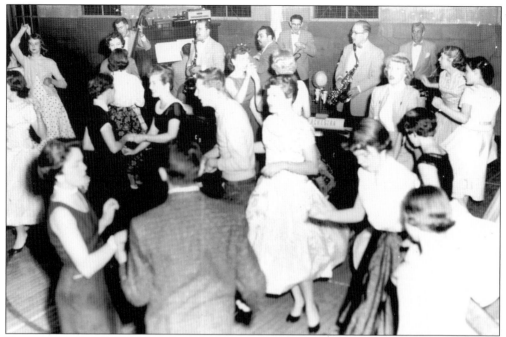

Young couples dance the night away at the YMCA Blossom Ball on May 11, 1956.

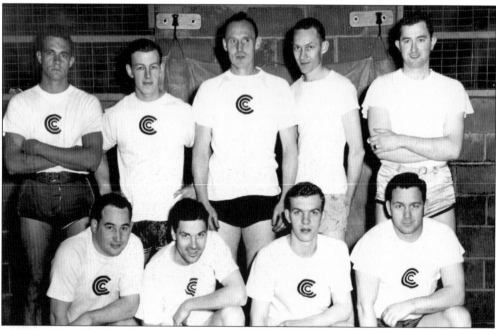

The Continental Can Company team went 14-0 during the 1950–1951 season to take the YMCA league basketball championship. Pictured from left to right are (first row) Paul Baker, Joe Mosser, Paul Callihan, and Herb Christianson; (second row) Roy Unklesby, Howard Callihan, Martin Hughes, Harry Murgatroyd, and Danny Baker.

Four

DISASTERS

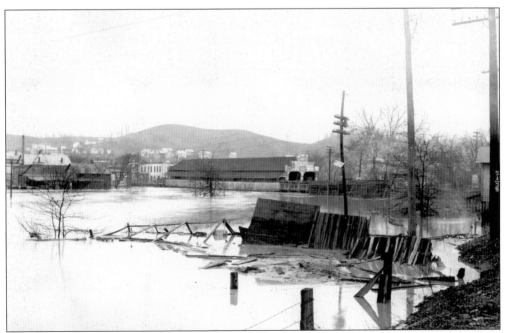

In March 1907, Wills Creek overflowed into the countryside and streets of Cambridge due to extensive flood rains. It was recorded that there was over 2.2 feet of floodwaters that covered the lands in Cambridge. This particular picture shows the double covered bridge in the background and numerous areas of debris in the foreground.

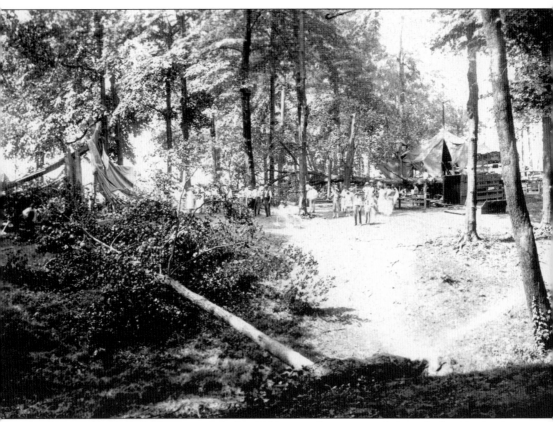

At approximately 7:00 p.m. on July 30, 1931, a windstorm ripped through the Cambridge city park area. This particular picture shows onlookers surveying the damage done to the carousel and surrounding picnic areas. Needless to say, the fun stopped short on this summer night in Cambridge.

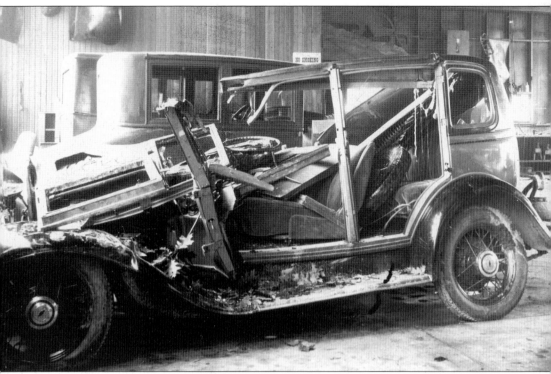

The same windstorm also caused structural collapse in various other areas of the park. Pictured here is a car that was demolished by a tree that crashed into the garage where the car was parked.

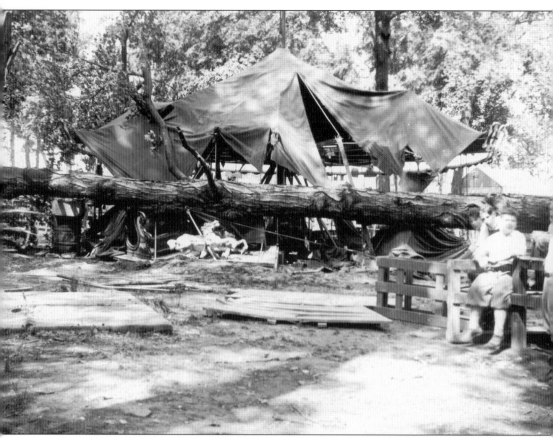

The saddest part to the story of this storm was the destruction of the carousel by the falling of this humongous tree. Some men observe the damage to the carousel and see the painted horses on the ground and the tent ripped. Although the damage to the carousel was devastating, especially for the eager children, it was very fortunate that no one was hurt during this particular windstorm.

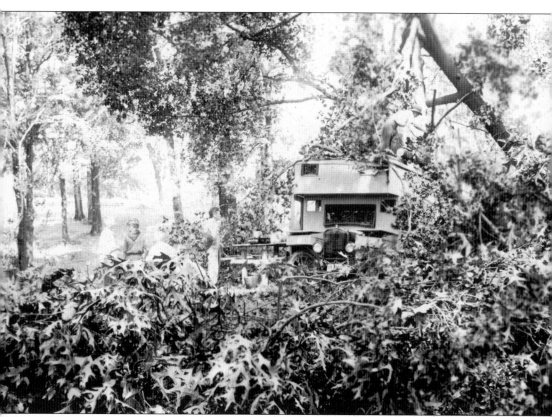

Pictured here are men and children attempting to help clear the debris and branches from the storm damage. A truck was driven in close so as to cut away the dangling branches and possible dangers.

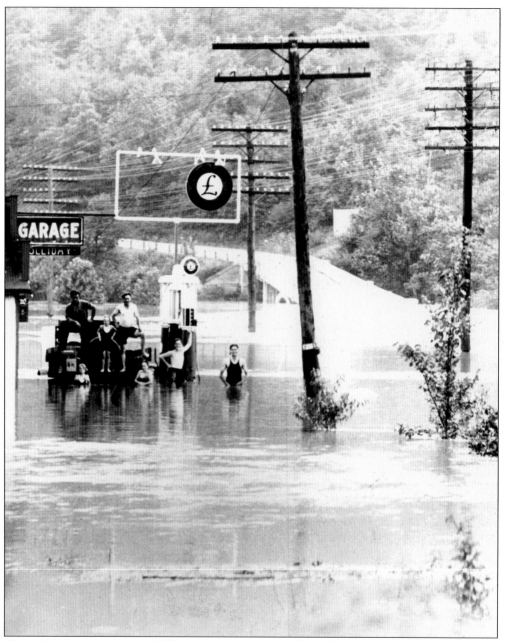

Shown here are the August 1935 floodwaters outside of Holliday's Garage at 1501 Woodlawn Avenue in Cambridge. Seen behind is the bridge on Nicholson Hill (Old Route 21). The depth of the water can be seen as the level is well over the axle of the truck and at the waist of the young man on the right. Pictured from left to right are Billy Cater, an unknown girl, Max Cater, Bates ?, and three unidentified people.

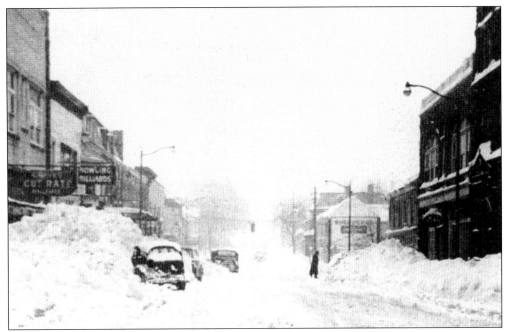

The blizzard of 1950 also prevented the use of transportation on the roads; all state and federal highways were blocked. The majority of the snowfall was in a 35-hour continuous span, and from 3:00 a.m. on through to the next day, 40 employees of the Ohio Highway Department manned 10 plows that were at work until the roads were cleared for use.

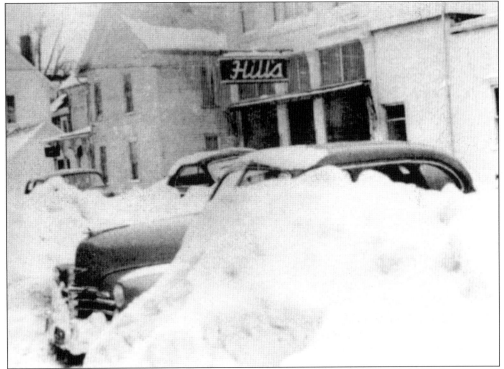

Digging cars out was no simple task.

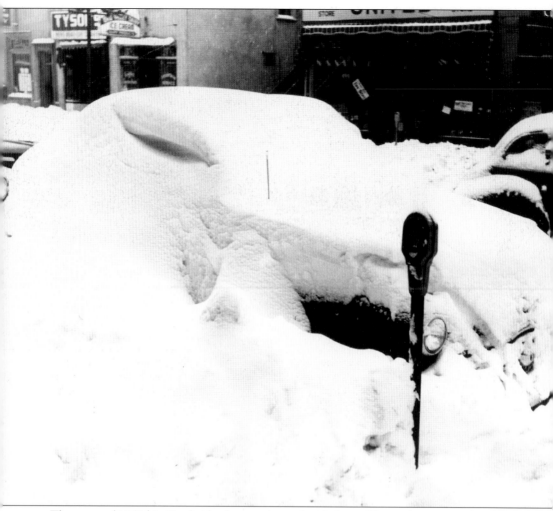

The snow of 1950 hit Cambridge by surprise and with force. The inches accumulated into feet within hours. Pictured here is a car buried in the effects of the blizzard along Wheeling Avenue in Cambridge. This storm was called the "Blizzard of the Century."

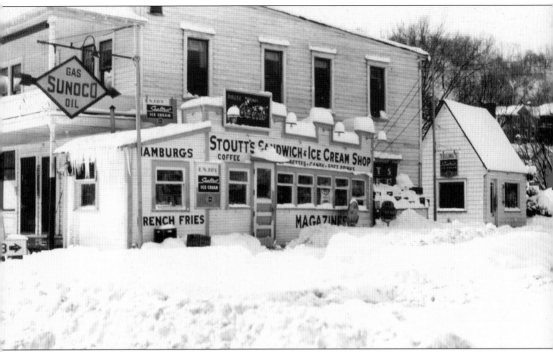

Taken on November 26, 1950, amidst the blizzard of that winter, this photograph shows the accumulation of snow outside Stoutt's Sandwich and Ice Cream Shop on Dewey Avenue in Cambridge. Stoutt's was one of many businesses and homes in Cambridge that was affected by the large snowdrifts of the infamous blizzard of 1950.

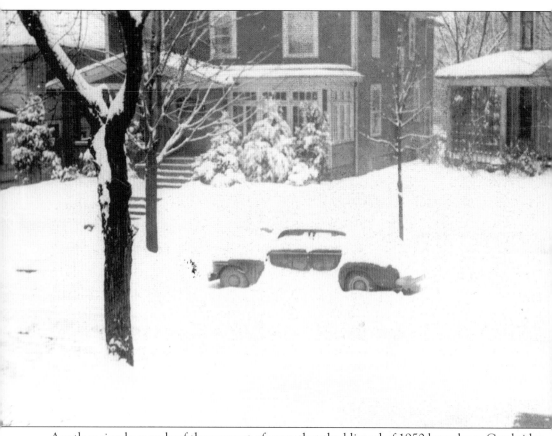

Another visual example of the amount of snow that the blizzard of 1950 brought to Cambridge is a car covered in snow across Ninth Street. The vehicle is pictured in front of the Bell family residence. There was more than 20 inches of snowfall during the week of Thanksgiving, with winds topping 85 miles per hour.

Pictured at the Ninth Street school building in 1952, the Cambridge Fire Department demonstrates a rescue to teach children about fire safety.

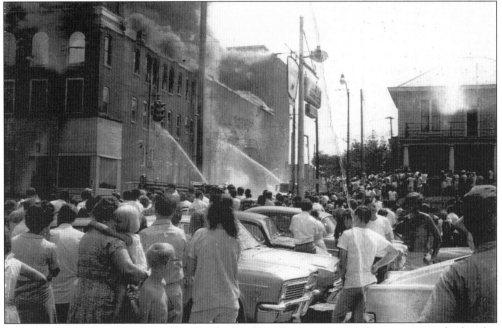

Dozens of onlookers watch as the Cambridge Fire Department works to extinguish this fire on Wheeling Avenue in an unknown building. The start of the fire was deemed to be accidental or possibly an electrical malfunction. The damage was critical, and the building had to be rebuilt structurally.

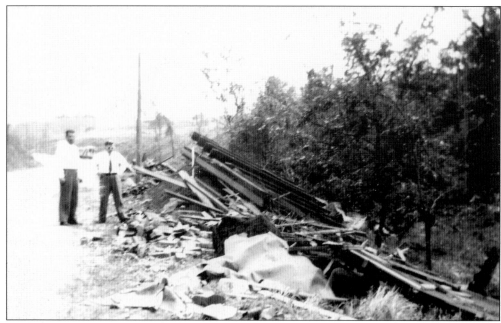

These two preachers (last names Eby and Shriver) observed the damage done to a house alongside a road in Cambridge. A tornado swept through the city on June 25, 1968. It was spawned by Tropical Storm Candy. Substantial damage and destruction was assessed to many homes in the Cambridge area, and there were fatalities and injuries.

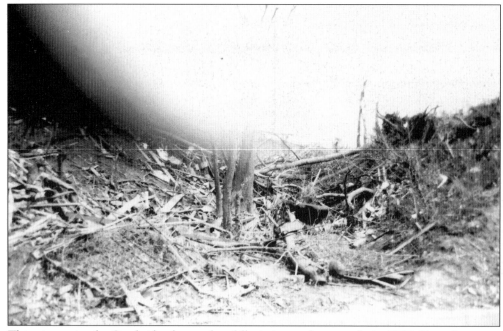

This picture is of a Cambridge home that fell victim to the tornado in 1968. Everything was carried away but the bedspring seen in the lower left of the picture.

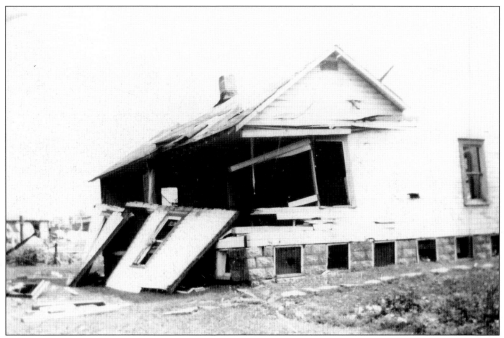

This house was left standing, but the damage had been done. The family that resided in this Cambridge home was blown through the side of the house. All were badly injured, but there were no fatalities.

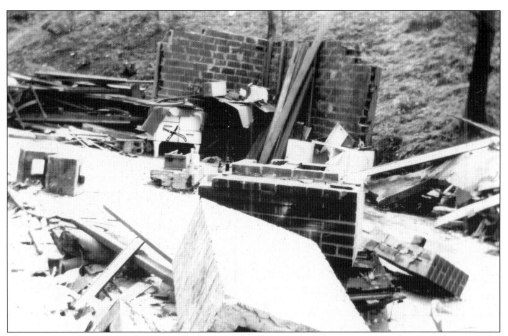

The 1968 summer tornado that shocked Cambridge proved that some people were not so lucky in times of disaster. Every resident in this particular home was killed during the destruction of the structure. All that was left standing was the kitchen stove pictured in the rubble.

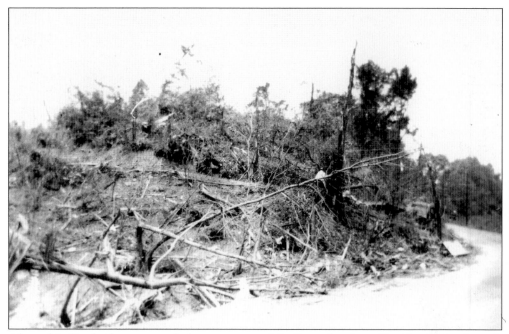

Along this Cambridge-area road, there was a car full of travelers from Florida passing through the city on their way to visit relatives up north. The tornado caught them off guard and took the car into the air along with everyone inside. Some of the bodies were never found, only parts. The man pictured lodged against the tree is dead, waiting to be identified and properly buried.

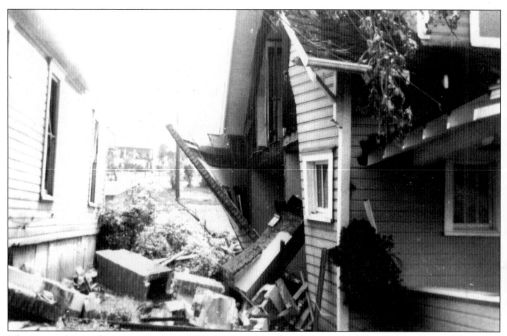

The tornado in the summer of 1968 also produced sad stories of family fatalities. Trees are pictured on the roof of this house and amongst the rubble. The damage looks minimal, yet in this instance, the whole family was killed, with the exception of a 12-year-old boy.